IMAGES
of America

BOSTON'S RED LINE
BRIDGING THE CHARLES FROM
ALEWIFE TO BRAINTREE

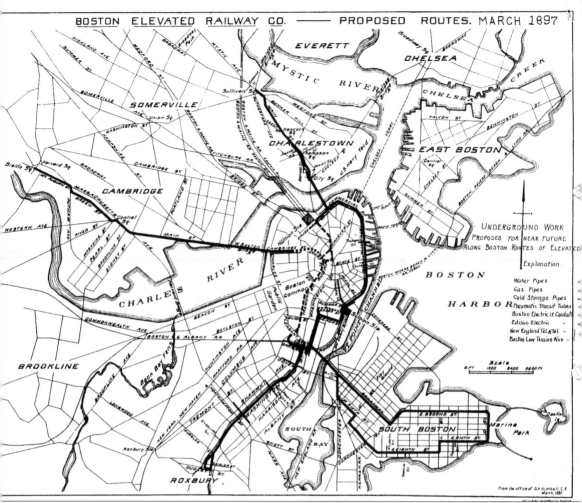

This March 1897 map shows the Boston Elevated's planned system as approved by the state legislature. Although the Roxbury, Charlestown, and Atlantic Avenue elevated lines were completed as planned, the Cambridge line was built as a subway and the South Boston line was quietly dropped as impractical.

IMAGES
of America

BOSTON'S RED LINE
BRIDGING THE CHARLES FROM
ALEWIFE TO BRAINTREE

Frank Cheney

ARCADIA

Copyright © 2002 by Frank Cheney.
ISBN 0-7385-1047-5

First printed in 2002.

Published by Arcadia Publishing,
an imprint of Tempus Publishing, Inc.
2A Cumberland Street
Charleston, SC 29401

Printed in Great Britain.

Library of Congress Catalog Card Number: 2002105264

For all general information contact Arcadia Publishing at:
Telephone 843-853-2070
Fax 843-853-0044
E-Mail sales@arcadiapublishing.com

For customer service and orders:
Toll-Free 1-888-313-2665

Visit us on the internet at http://www.arcadiapublishing.com

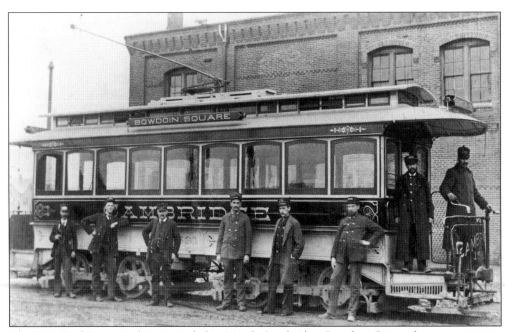

The West End Street Railway regarded its North Cambridge–Bowdoin Square line as important enough to be assigned its newer and better cars, such as No. 1531. Having been recently built by the Newburyport Car Company, the car is shown at the North Cambridge car house in December 1891.

CONTENTS

INTRODUCTION

When the Massachusetts Bay Transit Authority (MBTA) took over the complete Boston area transit system in 1964, it color-coded the route maps. The Cambridge–Dorchester subway line was designated as the Red Line in recognition of the city of Cambridge, which has long been known as the Crimson City. This photographic history traces the development of Cambridge's main transit artery and its place in the Boston transit system.

Cambridge was settled in 1631 as Newtowne, a name it retained until 1638. The city's separation from Boston by the Charles River hindered ties between the two towns. This changed when Cambridge resident and Supreme Court justice Francis Dana headed a project to build the first West Boston Bridge over the Charles River. It opened to travel on November 23, 1792. Rebuilt and widened in 1854 after years of heavy use, the bridge achieved fame in Longfellow's poem "The Bridge" and became known as the Longfellow Bridge. The name still applies to the present bridge, which carries the Red Line, automobiles, and pedestrian traffic across the Charles.

In 1826, omnibuses began operating between Harvard Square and downtown Boston on an hourly schedule. Soon, they were running every 10 minutes, an indication of the growth of Cambridge. The next improvement in Cambridge-to-Boston transit occurred on March 26, 1856, when the Union Railway Company introduced horse railway service between the two cities, the first street rail service in the Boston area.

In the fall of 1887, the newly created West End Street Railway had consolidated all the horse railways into one large system and was considering the use of cable cars on a number of busy routes. In a last-minute change of plans, the West End Company accepted an offer by the Thomson-Houston Electric Company to install electric trolley cars at its own expense on the Bowdoin Square–North Cambridge line. The cars began operation on February 16, 1889, with great success.

Although these improvements greatly enhanced mobility in the area, numerous plans were put forward to provide rapid transit based on the New York model—elevated railways. One such plan was offered in 1884 by inventor Joe V. Meigs, who incorporated the Meigs Elevated Railway Company to build an elevated line between Boston and Cambridge with his unique monorail system.

On July 2, 1894, the Boston Elevated Railway Company was organized to build a conventional elevated railway system that would link downtown Boston with Cambridge, Roxbury, Charlestown, and South Boston. Joe V. Meigs managed to acquire the franchise and refused even to consider the use of electric power to run the trains, insisting that steam power was superior and safer, a stance that alienated investors and the public alike.

Unable to raise funds, Meigs offered the franchise to the big West End Street Railway for $150,000—an offer turned down by the conservative West End management. This move greatly dissatisfied several major stockholders of the West End, including Eben Jordon (Boston's leading retail merchant) and Col. William A. Bancroft (later major general), one of Cambridge's leading citizens. Bancroft, a lawyer and former mayor of Cambridge, had served three terms in the state legislature. He had also served as superintendent of the Cambridge Horse Railway from 1885 to 1887. Bancroft and Jordon, with the support of bankers J.P. Morgan and Kidder-Peabody Company, acquired the Boston Elevated franchise from Meigs and staged an intensive proxy fight, resulting in the seating of a new West End board supportive of the Jordan-Bancroft group.

On November 24, 1896, the new board of directors of the West End Street Railway voted to lease the entire system to the new Boston Elevated Railway, effective on December 9, 1897. By October 1899, Bancroft, who had been vice president of Boston Elevated, assumed the presidency.

On January 20, 1899, ground was broken for Boston's new elevated system. It would consist of four main routes fanning out from downtown Boston to Roxbury, Charlestown, Cambridge, and South Boston, with an additional route along Atlantic Avenue to serve Boston's busy waterfront.

The South Boston elevated line was quietly dropped as being impractical, and work on the Cambridge elevated was due to begin shortly after completion of the new West Boston (Longfellow) Bridge. By the bridge's opening in 1906, public opinion in Cambridge had hardened against the idea of an elevated line over the main business streets of the city, with calls for a subway being voiced by the business, civic, and political elements. Finally, in late 1906, after heated and intense negotiations, Boston Elevated agreed to build a subway from Harvard Square to the Longfellow Bridge at its own expense, one of only three privately financed subways in the United States. Despite a hot debate over the number of stations the line would have, the State Railroad Commission mandated on July 28, 1908, that three stations be built for the new line—Harvard Square, Central Square, and Kendall Square. Construction of the Cambridge Subway got under way on the morning of May 24, 1909, at the corner of Massachusetts Avenue and Bay Street.

Soon, proposals were being submitted for an extension of the new line beyond the planned terminal at Park Street under the existing Tremont Street Subway in downtown Boston. The most viable was deemed to be an extension from Park Street to the South Station railroad terminal. This downtown extension received approval on January 4, 1911, and was quickly followed by approval of a further extension to Andrew Square in South Boston. Also, construction on the original section of the Cambridge tunnel was moving rapidly ahead. On July 8, 1910, Bancroft led an inspection tour of the completed section of the tunnel in his large automobile. On October 2, 1911, the first of the large new tunnel cars arrived. Exceptional in size and revolutionary in design, these cars set the pattern for future rapid-transit practice. Designed by John Lindall of the Boston Elevated's equipment department, they were built by the Standard Steel Car Company of New Castle, Pennsylvania. The Standard Steel Car Company was represented by James Buchanon Brady (the famous Diamond Jim Brady, who made his fortune as a supplier and salesman of railway equipment).

At 5:00 a.m. on March 23, 1912, the Cambridge Tunnel opened to the public. The first train departed from Harvard Square for Park Street in Boston at 5:24 a.m., with just over 300 passengers on board. Total cost to the Boston Elevated for the tunnel was $10.4 million, plus $1.3 million spent by the city of Boston for the Beacon Hill Tunnel from Charles Street into Park Street. The new Cambridge Tunnel was an instant success, reducing travel time from Harvard Square to downtown Boston from 25 minutes to 8 minutes. Ridership increased when the sections to Washington Street (today's Downtown Crossing) and South Station opened on April 4, 1915, and December 3, 1916, respectively.

Extension of the tunnel line continued beyond South Station with the opening of Broadway Station, on December 15, 1917, and Andrew Square Station, on June 29, 1918. Officially designated as the Dorchester Tunnel, this new section was referred to by the general public as the Cambridge Tunnel. The extension provided an unexpected bonus to Cambridge merchants, as residents of South Boston and Dorchester were afforded a fast, direct ride to the shopping areas of Harvard and Central Squares.

After the extension of the Cambridge-Dorchester Tunnel to Andrew Square, the severe overcrowding at the big Dudley Street terminal on the Washington Street elevated line was finally relieved. Andrew Square, however, soon became badly overcrowded, reviving demands of Dorchester residents for direct rapid-transit service into the heart of their populous area.

After intensive study, the Boston Transit Commission, the Boston Elevated Railway, and the New Haven Railroad reached agreement on what was called the Dorchester Circuit Plan, which called for operation of rapid-transit trains from Andrew Square through Uphams Corner, Mount Bowdoin, and Mattapan, looping back to Andrew Square via the Shawmut Branch through Ashmont, Fields Corner, and Savin Hill.

Although the Shawmut Branch served a less populous area than the Midland Division did, key members of the state legislature insisted on building the Shawmut Branch first. The real estate development it would spur would benefit a number of politicians. Thus, construction via the Shawmut Branch to Mattapan was given approval on March 23, 1923.

With construction off the Dorchester rapid-transit line well under way, the Metropolitan Planning Commission issued a report in December 1926 to urge the construction of a rapid-transit branch from the new Dorchester line through Quincy to Braintree and another extension from Harvard Square under Mount Auburn Street to Waltham. These two extensions would be discussed for 40 years before any action would be taken.

At 5:05 a.m. on December 21, 1929, trolley operator Bob Nelson, a veteran of 50 years of service, ran the first car from Mattapan to Ashmont, thus marking completion of the Shawmut Branch section of the Dorchester rapid-transit loop.

Near the end of World War II, the state created the Coolidge Commission to recommend a greatly improved and expanded rapid-transit system to meet the Boston area's postwar needs. This report resulted in the creation of the Metropolitan Transit Authority (MTA) in September 1947, which replaced the Boston Elevated Railway Company. In 1964, the newly created MBTA replaced the MTA. On August 15, 1947, as part of a new color-coding system for transit maps, the Cambridge–Dorchester line was designated as the Red Line. In 1966, the Massachusetts Bay Transit Authority began construction of the South Shore extension to Braintree, which was completed on March 22, 1980. By March 1985, the Cambridge side of the line was extended to the Alewife station.

Today's Red Line is a vital part of Boston's transit system. From Alewife to Braintree, it links the northern and southern suburbs via downtown Boston and Cambridge and is used by 225,400 riders each weekday.

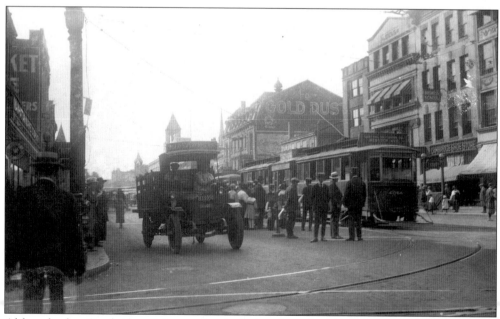

Although the Cambridge Subway absorbed the through riders from Harvard Square to downtown Boston, local Cambridge passengers continued to depend on surface trolleys for shopping and business trips. In this early-1920s scene of busy Central Square, bundle-laden riders are boarding an articulated trolley bound for Webster Avenue and Union Square. The Boston Elevated Railway's John Lindall designed the articulated trolley car as well as the new Cambridge Subway cars.

One

Early Transit from Cambridge to Boston

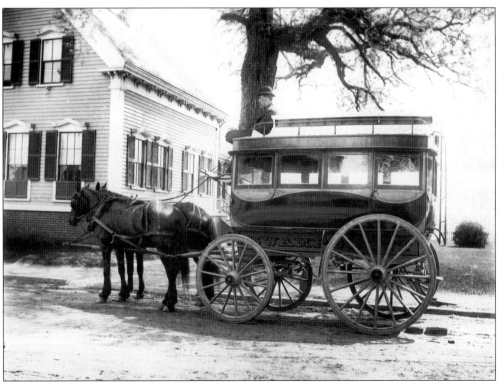

The first local public transportation in the greater Boston-Cambridge area was provided by omnibuses. As horsecars and electric cars replaced the omnibuses on busy routes, many of them were sold off to suburban or rural operators. Pictured on May 22, 1901, this omnibus is seen in Swampscott, where it carried riders to the local railroad stations.

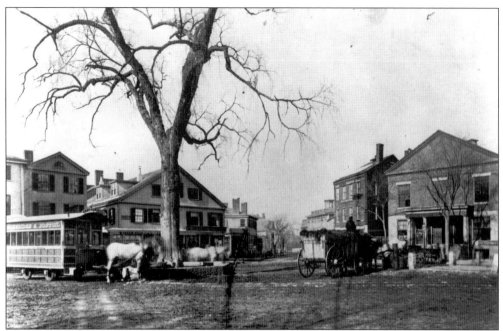

In this late-1850s view, Harvard Square looks almost rural. To the left is one of the original type of horsecars used on the Harvard Square–Bowdoin Square line. In the center, Brattle Street stretches off into the distance. To the right, the Cambridge Gas Light Company occupies the Lyceum Building, which was later acquired by the Harvard Co-operative Society.

Two horsecars of the Union Railway Company of Cambridge are pictured in the center of a rather placid Harvard Square in the mid-1870s. The Colledge House occupies the background, with the tower of the First Parish Church visible to the right. The upper floors of the Colledge House served as a dormitory for Harvard students, and assorted shops occupied the first floor.

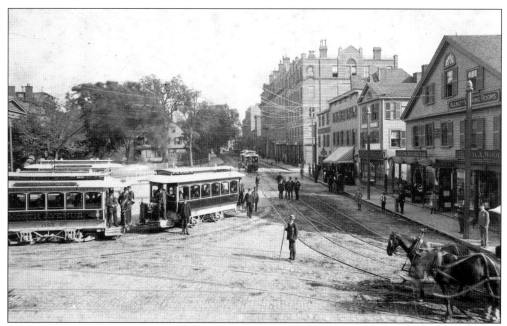

It is a bright midsummer day in Harvard Square in this 1889 scene. In the center of the square are the electric trolleys that were installed in February 1889 by the Thomson-Houston Electric Company of Lynn. A horsecar approaching from Central Square is passing the Wadsworth House, visible through the trees. The brick block to the right has been replaced by the Holyoke Center.

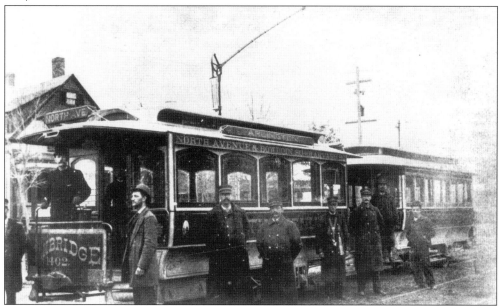

In the spring of 1889, electric trolley No. 1402, towing a horsecar as a trailer, pauses in front of the North Cambridge car house (out of frame). A former horsecar electrified by Thomson-Houston in February 1889, No. 1402 proved too small to handle the steadily increasing ridership and was sold to Austin, Texas, in 1892 as larger cars were put in service. (Courtesy Cambridge Historic Commission.)

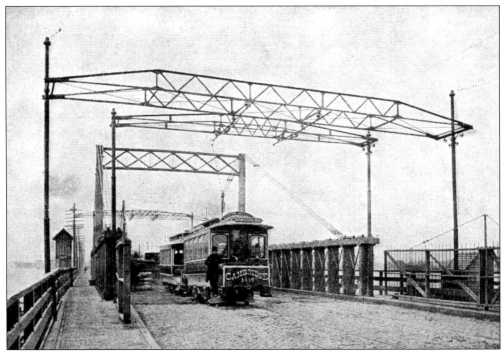

The West Boston Bridge is pictured in 1889 with a train of Thomson-Houston electric cars bound for Bowdoin Square in Boston. This bridge was first opened in November 1792 and was extensively improved and widened in 1854. However, it would have been totally unsuitable to carry the Cambridge Subway trains and was replaced by the present bridge, completed in 1906.

During the summer months, Cambridge trolley riders had the pleasure of riding on open trolleys. This one is pictured at the North Cambridge car house before departing for Bowdoin Square in Boston.

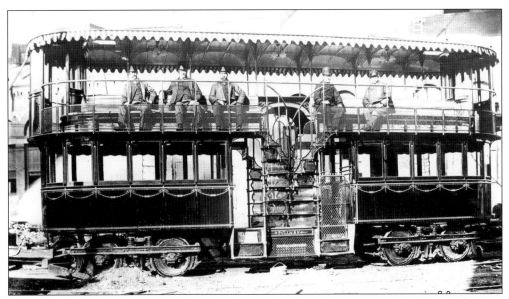

With ridership increasing on the Harvard Square–Bowdoin Square route, the West End Street Railway considered the use of double-deck cars on the busy line and leased such a car from the Pullman Car Company for trial operation. Seating 80 passengers (40 on each deck, with the operator's cab on the upper deck), the 18-ton car was in operation from November 1891 through March 1892, when it was deemed unsuitable due to its slow loading of riders and was returned to the Pullman Car Company. Pullman sold the car to a company in Louisville, Kentucky.

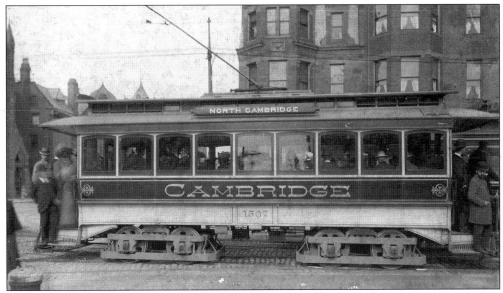

The heavy ridership on trolley cars linking Harvard Square with downtown Boston is exemplified in this view of a Cambridge-bound car at Massachusetts Avenue and Boylston Street in Boston. The photograph was taken in 1897, when construction of the planned Cambridge elevated line had already been approved but delayed, pending construction of the new West Boston Bridge. By the time the new bridge had been completed, the decision to build a subway rather than an elevated line had been made.

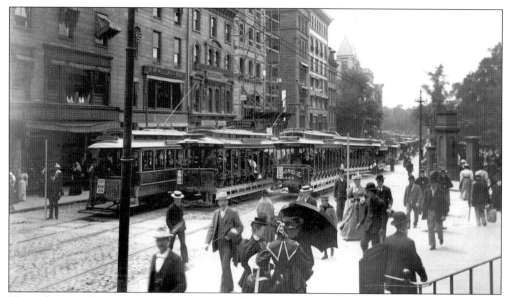

Not only were the streetcars themselves usually overcrowded with riders, but many of the main thoroughfares were becoming congested with the increasing numbers of streetcars needed to carry the growing ridership. This situation is exemplified in this view of downtown Boston as a trolley bound for Harvard Square moves slowly through a long line of other trolleys at Tremont and Park Street next to Boston Common. Park Street later became the Boston terminal for the Cambridge Subway.

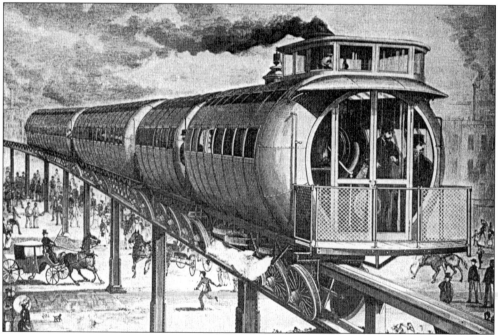

An early proposal for rapid transit between Cambridge and Boston was put forth by the Meigs Elevated Railway Company in the mid-1880s. The proposal featured a collision-proof steam-powered monorail train, as seen in this investment prospectus issued by the company. The train featured both horizontal and vertical wheels gripping a center rail, making a derailment impossible.

14

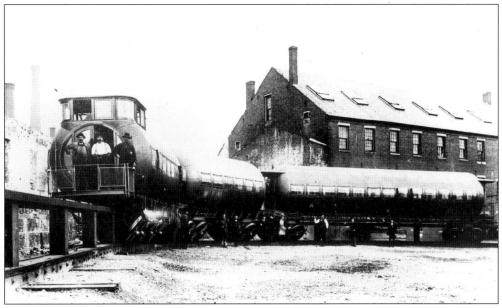

No, this is not a Jules Verne creation—it is Capt. Joe V. Meigs's patented monorail elevated train, seen here in 1888 on the grounds of the J.P. Squires meat-packing plant in East Cambridge. Demonstration rides were given over a quarter-mile track to prospective investors, of which there were few. J.P. Squires, however, had invested in the scheme.

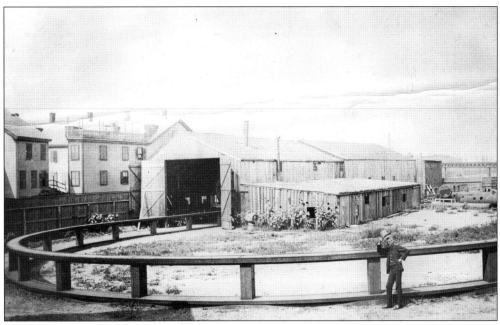

The Meigs car shop and test track in Cambridge are shown here. The man tipping his hat could be Meigs himself. Meigs made $50,000 in 1888 for rights granted to the Lake Street Elevated Railway Company of Chicago to use the Meigs system, which was discarded in favor of conventional elevated railway technology.

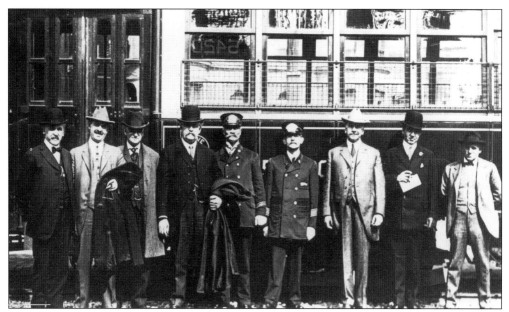

Maj. Gen. William A. Bancroft, president of the Boston Elevated Railway, was a firm manager and a skilled politician. With an outgoing personality, he eagerly sponsored activities that made Boston Elevated look good, such as this inspection trip of the new Boylston Street subway on October 3, 1914. From left to right are James Smith, superintendent of transportation; Pat McGovern; John Bright, a major stockholder in the elevated company; Alderman Woods of Boston; car crewmen Sam Smith and Bob Power; William A. Bancroft; M.C. Brush, vice president; and Harry Nawn of the Hugh Nawn construction firm, a major contractor on both the Cambridge and Boylston Street subways.

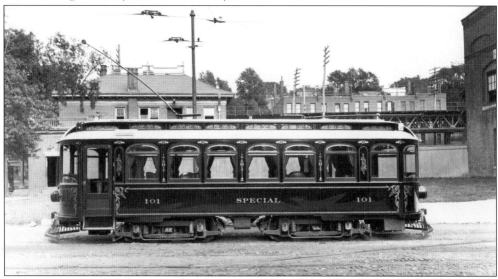

The Boston Elevated Railway provided Bancroft with two private cars, one a deluxe parlor car painted black and the other a private snowplow painted white. Both cars were numbered 101 in keeping with 101 Milk Street, the address of the Boston Elevated office building. Parlor car No. 101 carried Bancroft and his friends as far afield as Newport, Rhode Island; Beverly Farms; and Springfield. The car is seen here at the Bartlett Street shops when new in 1904.

16

Two

WILLIAM A. BANCROFT
AND THE
CAMBRIDGE TUNNEL

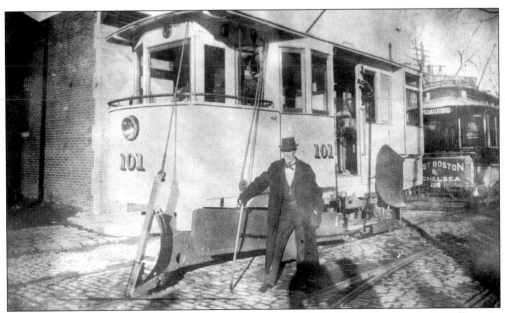

Probably the most unique unit of rolling stock on any American transit system was William A. Bancroft's private parlor plow, also numbered 101 and painted white. It is seen here at the Bartlett Street shops when it was new. Fitted with upholstered seats and an observation balcony at each end, the car allowed Bancroft to supervise snow-removal activities in comfort.

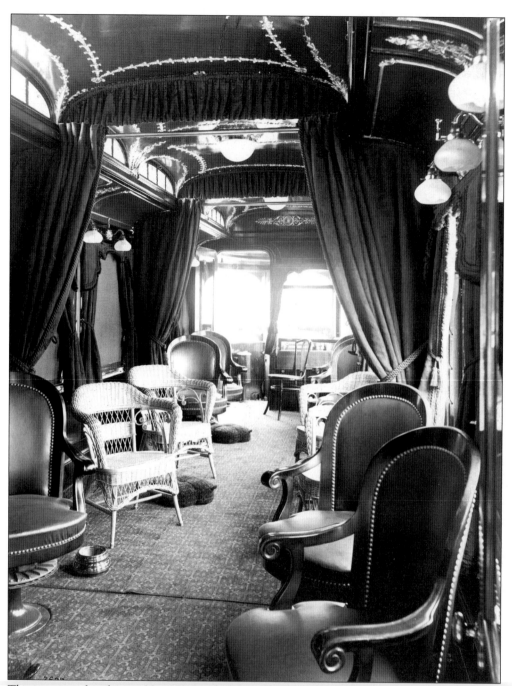

The interior of parlor car No. 101 was lavish, with thick plush carpeting and velvet and silk draperies in various shades of green and gold, providing a suitable setting for the comfortable leather swivel parlor chairs and movable wicker chairs and cushions. Note the brass spittoon in the foreground, typical of the period.

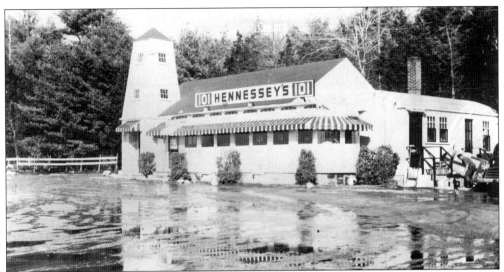

After William A. Bancroft retired from the presidency of the Boston Elevated Railway in 1916, parlor car No. 101 saw little use except for a few trips by the new company president, Mathew C. Brush, and several inspection tours for the state railroad commission. Finally, in 1932, the car body was sold, becoming a portion of Hennessey's 101 Ranch, a nightclub on Route 1 in Foxboro.

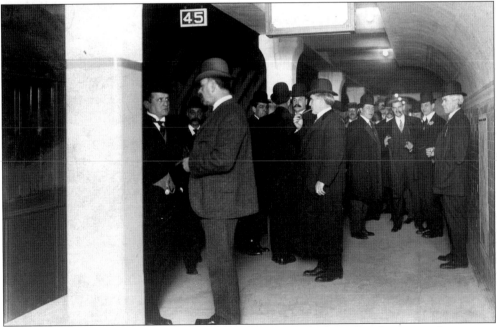

Along with the Cambridge Subway, Bancroft played a lead role in the planning and equipping of the Boylston Street Subway and the Washington Street Subway in Boston, built by the Boston Transit Commission and operated by the Boston Elevated Railway Company. On November 23, 1908, Bancroft provided an eight-car train of new steel elevated cars for an inspection trip through the newly completed Washington Street Subway for 1,000 invited guests, including Boston mayor John F. Fitzgerald, the father of Rose Kennedy. The mayor is seen wearing wing collar and conversing with Bancroft.

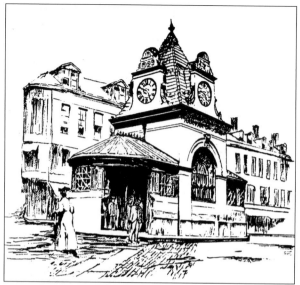

During the dispute between the Boston Elevated Railway (which wanted to build an elevated line) and the city of Cambridge (which insisted on a subway), the Boston Elevated offered a compromise that provided for an elevated line through Kendall and Central Squares with a short section of subway from Bay Street through Harvard and Brattle Squares. This drawing, dated March 15, 1900, depicts the station entrance, or headhouse, proposed for Harvard Square at that time.

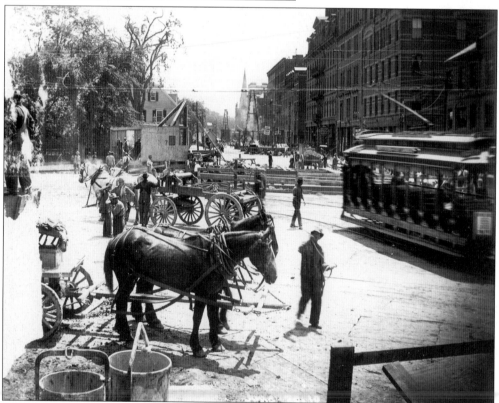

Harvard Square is pictured in a view looking down Massachusetts Avenue toward Central Square on June 20, 1910. Construction of the Cambridge Subway is under way. Workers and horses mingle with construction equipment as an open trolley heads toward Brattle and Mount Auburn Streets in an era when much construction work was still being performed by muscle power—both animal and human. The ever present Wadsworth House is visible beyond the trees, still a revered Harvard Square landmark.

20

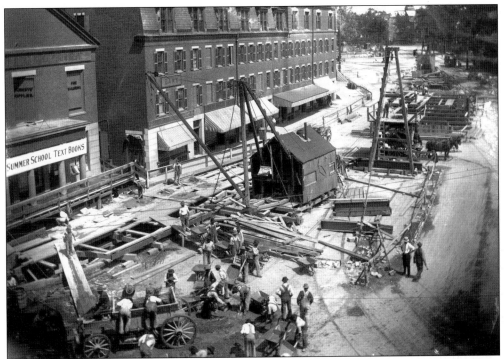

In this July 26, 1910 view looking toward North Cambridge, the Colledge House still dominates this side of Harvard Square, with the Harvard Co-operative Society offering summer school books in the former Lyceum Building. The square is almost completely torn up for subway construction, a situation that was repeated in the early 1980s, when the Cambridge Subway was extended to North Cambridge and Alewife. (Courtesy Cambridge Historic Commission.)

Taken on June 13, 1910, this photograph looks along Massachusetts Avenue into Harvard Square and toward Brattle Street. No traffic can be seen—only the gaping excavation for the new two-level Harvard Square subway station. The old Harvard Co-operative Society building is visible in the center. The facade of the three-story wooden building on the left was restored in 2001 under the auspices of the Cambridge Historic Commission. (Courtesy Cambridge Historic Commission.)

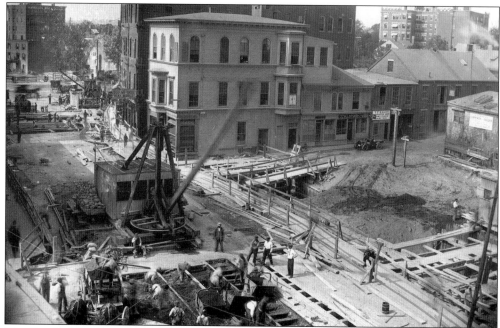

The Cambridge Subway extended a short distance beyond Harvard Square under Brattle Street toward Mount Auburn Street to reach the new Eliot Square car shops. In this September 26, 1910 view, Brattle Street is being torn up for the new subway. The new apartment building in the right background contrasts sharply with the old wooden structures in the foreground, which vanished as Harvard Square continued to develop.

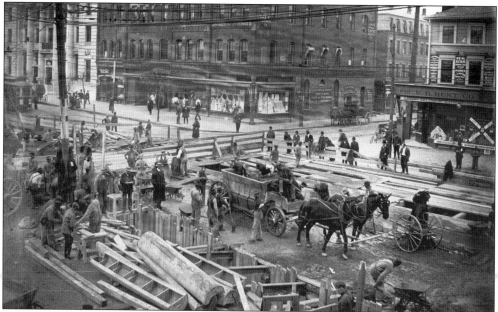

On May 3, 1910, Central Square is a sea of construction activity as work proceeds on the Central Square station of the Cambridge Subway line. The square is virtually devoid of traffic in this scene, except for the trolley car passing in front of the handsome Cambridge Savings Bank building, constructed in 1904 and designed by Chamberlin and Blackall.

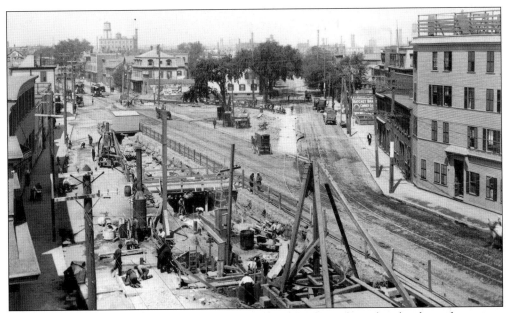

In this September 1910 photograph, Kendall Square is both residential and industrial in an era when many workmen found it convenient to reside within walking distance of their employment. Main Street is being excavated for the new subway, with Broadway extending off to the right. Two open trolleys are visible to the left on Main Street, but motor vehicles have yet to begin invading the streets of Cambridge.

As part of the Cambridge Subway project, the Boston Elevated Railway erected a major new shop complex to service both subway cars and surface trolleys. Two old surface car houses, along with various private properties, were demolished to make way for the new shop, which was known as the Bennett-Eliot facility. Pictured are the Murray Street stable and car houses dating from 1871 and 1888. To the right is the Cambridge Police Department's large mansard-roofed building, now the site of a motel.

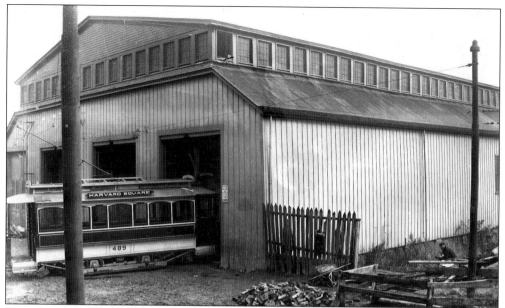

Directly across the street from the Murrày Street car house was the Boylston Street car house, which was built in August 1889 and extended through to Boylston Street. The car houses were built to service the Thomson-Houston electric cars and were both demolished in early 1911 to make way for the Bennett-Eliot maintenance facility. This photograph was taken on November 11, 1910.

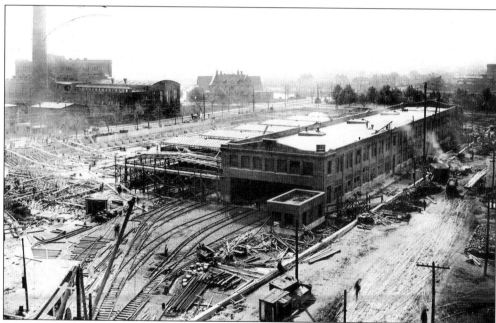

In this October 1911 photograph, we see the partially completed Eliot Square rapid-transit shop. The large building with the tall smokestack in the left background is the Boston Elevated's Harvard generating station. To its right is the familiar outline of the Harvard boathouse. Of the buildings in this view, the only one still standing is the boathouse. In the background are the private homes on the Boston side of the Charles River.

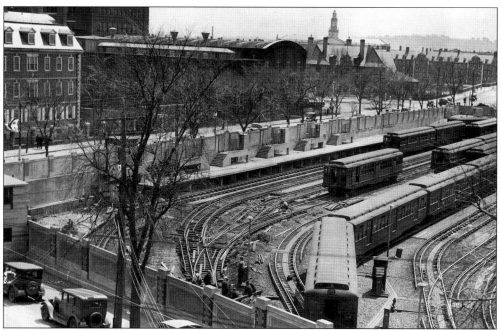

This view shows the Eliot Square rapid-transit shop yard on April 25, 1929. The power station has already been sold to Harvard University and will soon be replaced by new dormitory buildings. Beyond the boathouse and across the Charles River, new university buildings have replaced the private homes seen in the previous image. The station platform on the Boylston Street side of the yard was used only on days when football games or special events were held at nearby Harvard Stadium.

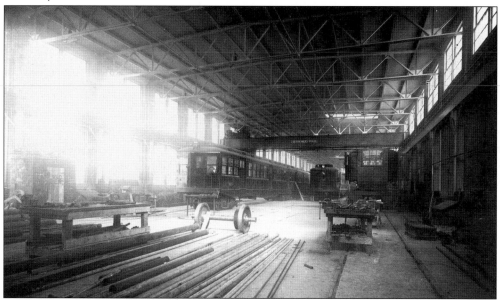

Pictured on February 15, 1912, is a section of the interior of the Eliot Square shops, nicknamed "Bancroft Hall" by the shop employees. At that time, work was under way to equip the new tunnel cars for service in time for the opening of the new Cambridge Subway on March 23, 1912, and the finishing touches were being put on the shop building itself.

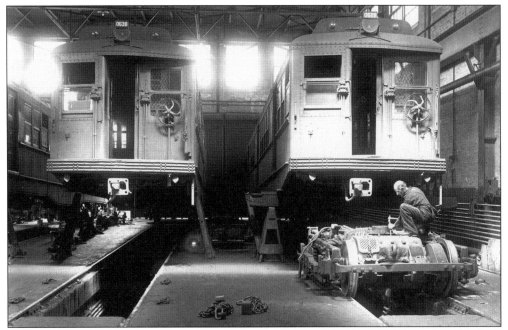

It is a quiet moment at the rear of the Eliot Square rapid-transit shop. Two of the large Cambridge Tunnel cars built by Diamond Jim Brady's Standard Steel Car Company sit on supports for routine maintenance. On the right, a repairman is at work on a six-ton motor truck from the car, which contained two 225-horsepower Westinghouse motors that powered these 43-ton cars dependably for 52 years. This view was taken on August 27, 1929.

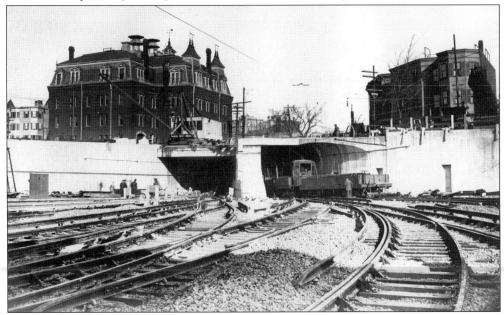

Here on November 27, 1911, we are looking from the Eliot Square car shop toward Brattle Square. The entrance to the Cambridge Tunnel is in the center, with a trolley construction train emerging. The handsome mansard-roofed building above the tunnel entrance was the headquarters of the Cambridge Police Department and is now the site of a motel.

26

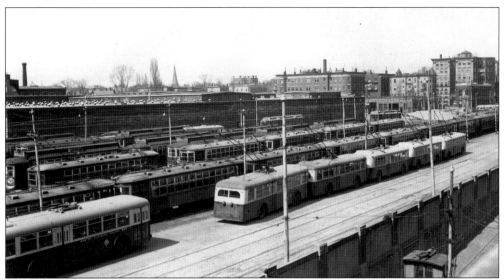

Adjoining the Eliot Square shop for subway cars was the Bennett Street car house and yard, where surface trolley cars were stored and maintained. Over the years, this facility was also used for trolley buses and motor buses. Taken from the roof of the Eliot Square shop building on April 20, 1944, this view looks across the trolley car storage yard toward the car house building, which is occupied by a variety of rolling stock. The apartment houses in the background are along Mount Auburn Street.

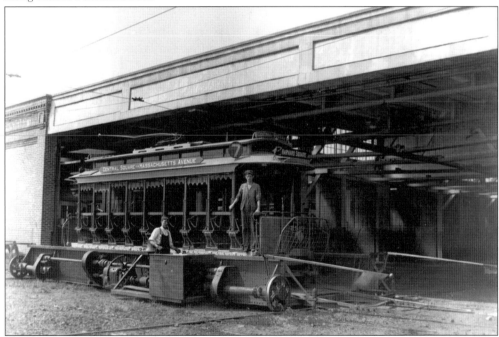

Taken on a May morning in 1912 at the new Bennett Street car house, this photograph shows two shop men moving an open summer trolley out to the yard on a transfer table. The table moved cars sideways to and from various tracks, avoiding a lot of time-consuming switching moves. The open trolley is No. 2519, which was built in 1901 by the Stephenson Car Company and was retired in 1920, when the use of open cars was given up.

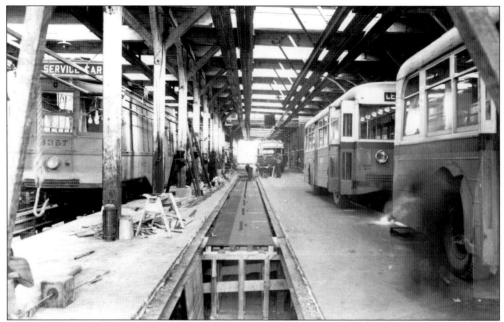

The interior of the Bennett Street car house is shown on November 30, 1949, with an assortment of streetcars and trolley buses. This facility was used to maintain streetcars from 1912 to 1958. It was used to service trolley buses from 1936 to March 1980, when it was closed and replaced by a modern facility in North Cambridge. (Courtesy Cambridge Historic Commission.)

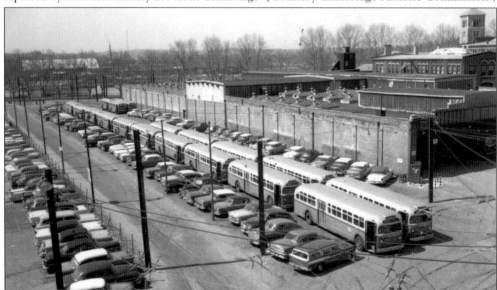

In October 1958, the easternmost section of Bennett Street car house was torn down and a section of the storage yard was leased to the city of Cambridge for public parking. By the time this view was taken on April 22, 1959, motor buses and employees' automobiles were being stored on the demolished section of the car house. The Eliot Square subway shop was closed on December 22, 1976, followed by the closure of Bennett Street car house in March 1980. The Kennedy School of Government and a commercial development now occupy the entire area. (Courtesy Cambridge Historic Commission.)

Three
HARVARD SQUARE TO PARK STREET

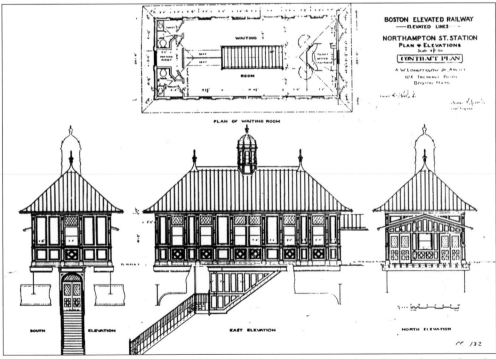

Had the planned Cambridge elevated line been built rather than the subway, this is what the stations at Kendall Square and Central Square would have looked like. They would have been identical to nine other stations on the Roxbury, Charlestown, and Atlantic Avenue elevated lines, all of which were built to a standard design provided by the noted architect A.W. Longfellow. The Boston Elevated Railway had hired Longfellow to design the stations and shop facilities on the new elevated system.

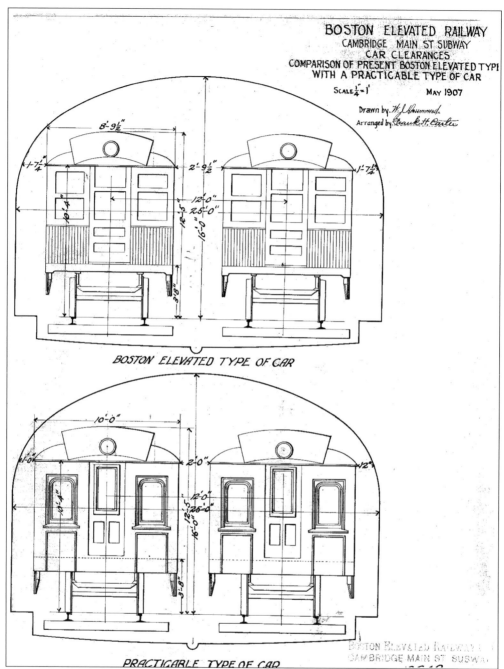

When the Cambridge Subway was being designed, it was decided not to connect it operationally with the existing elevated system. The engineers could therefore have a wide scope in station design as well as in the development of a new type of subway car that would be larger and more efficient in the boarding and alighting of passengers. This drawing portrays the tunnel clearances for the company's standard type of elevated car in comparison to the proposed large new Cambridge Subway cars.

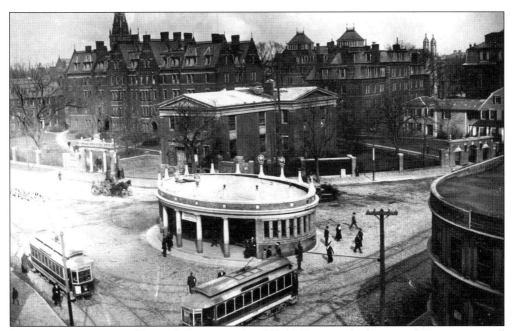

It is a quiet moment in Harvard Square on April 5, 1912, as we look across the square toward Harvard yard, with the handsome new circular headhouse entrance to the Cambridge Subway in the center of the square. Designed by Boston Elevated architect Robert Swain Peabody, the brick-and-stone structure harmonized well with the red-brick buildings of Harvard University and those in the square as well.

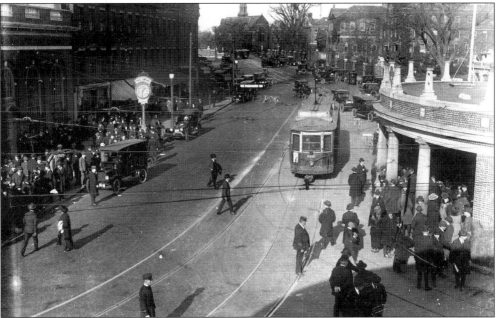

On November 6, 1920, Harvard Square is a scene of much activity, mostly pedestrian with few motor vehicles in sight. Judging by all the activity on this bright fall day, there must be a football game at nearby Harvard Stadium. This meant heavy riding on the Cambridge Subway, with trains running through to the Stadium Station next to the Eliot Square shops.

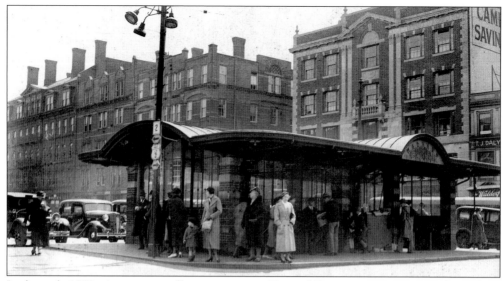

In the early 1920s, increasing traffic congestion in Harvard Square gave rise to complaints from motorists and traffic "experts" that the 1912 station building hindered visibility and was a hazard. In May 1928, the Boston Elevated replaced it with this copper-clad structure, which has been preserved through the efforts of the Cambridge Historic Commission after the station area rebuilding was completed in the mid-1980s. It now houses the popular Out of Town newsstand.

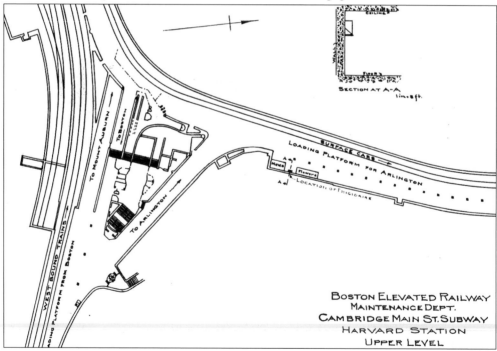

Located beneath Harvard Square is a well-designed two-level subway station with a tunnel for surface transit vehicles to deliver passengers directly to the subway platform level, providing efficient transfer between modes for the passengers. In addition, the surface vehicles avoid the heavy traffic in Harvard Square. Major rebuilding of this station was carried out in the mid-1980s, when the Cambridge Subway was extended to North Cambridge and Alewife.

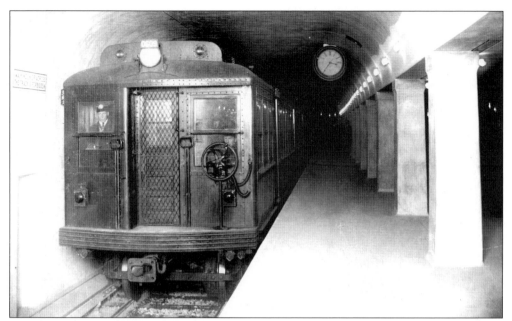

A train of new Cambridge Tunnel cars is about to leave Harvard Square for Park Street in Boston. The photograph was taken shortly before the subway opened to the public on March 23, 1912. The Boston Elevated went to great lengths to ensure that safe and efficient operation would characterize the line and provide the public with the finest transportation possible.

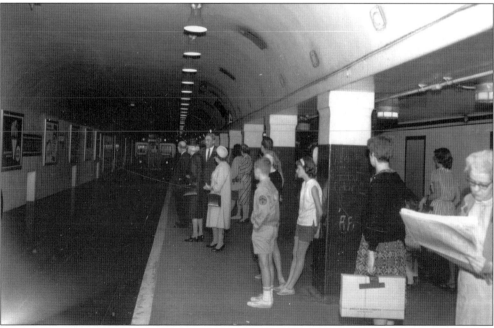

Here is the same inbound platform at Harvard Square on September 2, 1964 (52 years later), with little change in evidence except for the light fixtures and the removal of the big copper-framed Howard clock from the ceiling. This section of the station is now unused, since the train platforms were relocated around the corner under the square when the extension to North Cambridge and Alewife was built in the 1980s.

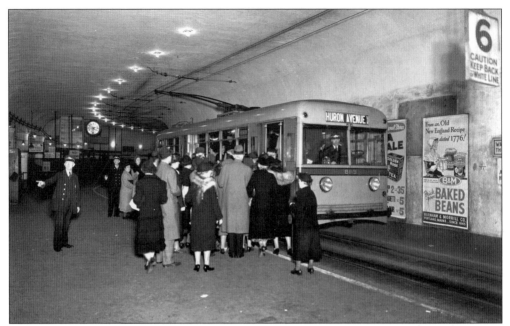

The Boston Elevated Railway was unique in its emphasis on ease of transfer for passengers. Surface cars and buses ascended ramps to the level of elevated stations at Dudley Street and Sullivan Square, and they descended to the subway level at Harvard Square to enable ease of transfer without using escalators or stairways. This homeward-bound crowd is boarding a trolley bus for Huron Avenue in November 1938.

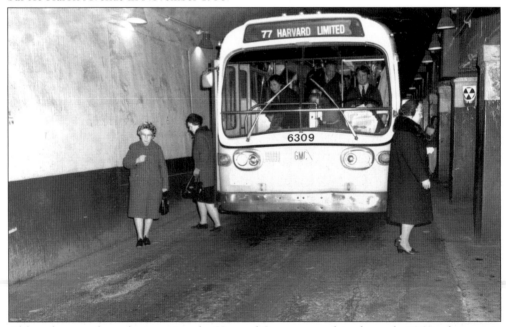

Although motor buses began using the Harvard Square tunnel in the early 1960s, their use is limited because of the diesel fumes that accumulate in the tunnel, especially in humid weather. On March 16, 1963, a bus from Arlington Heights is seen unloading Boston-bound riders at Harvard Square Station.

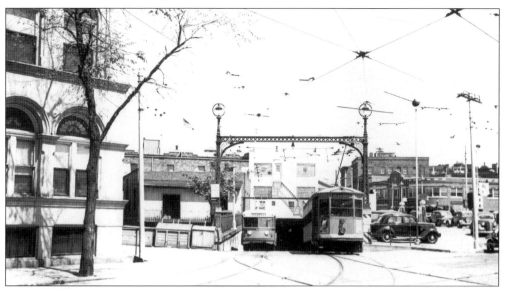

The tunnel for surface vehicles extends from Mount Auburn Street under Brattle Street and Harvard Square, emerging on Massachusetts Avenue at Cambridge Street. This photograph, taken on May 12, 1938, shows the Mount Auburn Street entrance to the tunnel. A trolley bus is emerging while a trolley car bound for Arlington Heights enters to pick up riders at Harvard Square Station.

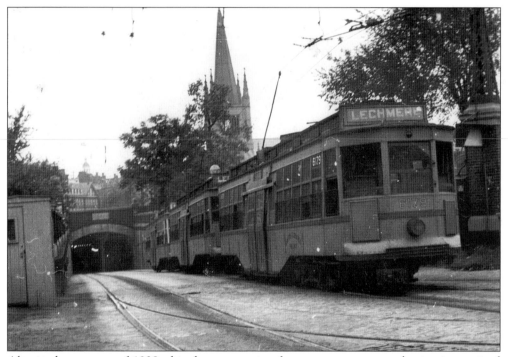

Also in the summer of 1938, this three-car train of center-entrance cars, having just arrived from Lechmere Square via Cambridge Street, is entering the Massachusetts Avenue entrance to the Harvard Square tunnel. It is bound for the Bennett Street car house, where it will be cleaned and serviced before returning to Lechmere Square.

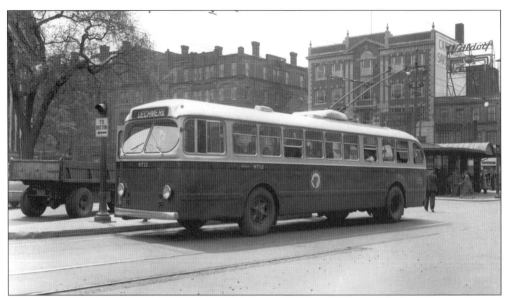

Not all surface vehicles were routed through the Harvard Square tunnel, as several routes remained on the surface. On May 24, 1950, this trolley bus is about to depart for Lechmere Square. In the background behind the familiar copper-clad subway entrance is the attractive Cambridge Savings Bank, built in 1923 and designed by Newhall and Blevins.

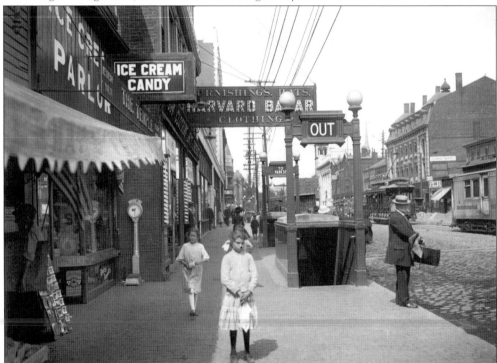

The candy store on the left seems to be an attraction for little girls in this summer 1912 view of busy Central Square in Cambridge. The new dark-marble subway entrances take up a minimum of sidewalk space. To the right, an open summer trolley and a white-painted postal trolley are headed to Harvard Square.

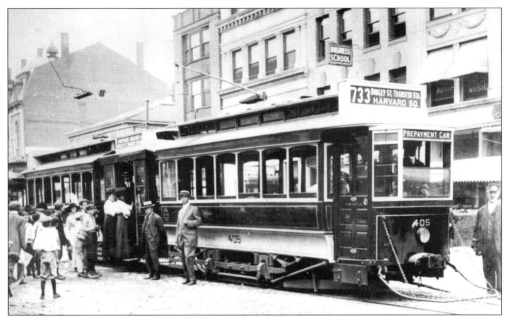

The long crosstown trolley route from Harvard Square to Dudley Street Station in Roxbury remained a busy route even after the Cambridge Subway was opened. Even today, it is one of the Massachusetts Bay Transit Authority's busiest bus routes. Here, in September 1912, riders board a new articulated trolley car in Central Square, headed for Dudley Street Station. This type of car was designed by Boston Elevated equipment engineer John Lindall.

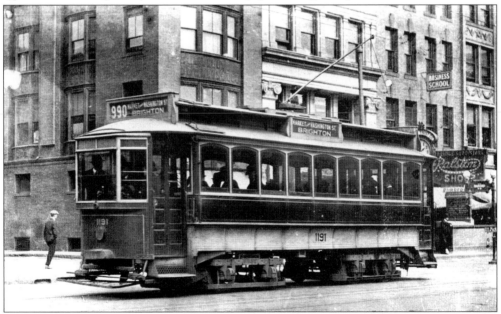

Central Square was always a busy transfer point between the Cambridge Subway and surface lines serving Somerville, Brighton, Boston, and nearby Cambridge points. The square was also a popular destination for shoppers. In this early-1920s view, car No. 1191 leaves Central Square for Market Street in Brighton. The car was scrapped in 1924, having been replaced by larger, speedier Type 5 trolleys.

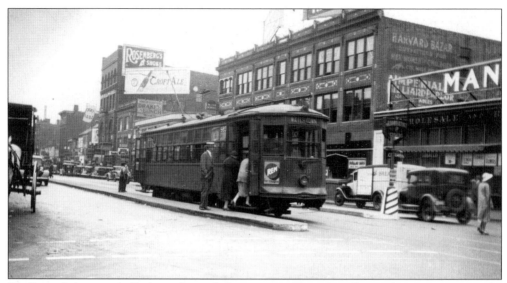

Traffic is light in usually busy Central Square as a Type 5 trolley picks up passengers for Watertown Square via Arsenal Street. Just behind the trolley is the Harvard Bazaar, a longtime popular retail store. Trolley No. 5830 was built in December 1924 by the Laconia Car Company and was retired in 1952.

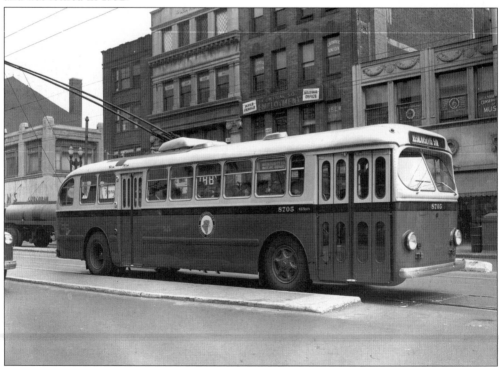

The last streetcar routes serving Central Square from Watertown and Harvard Squares were replaced in 1950 by trolley buses like this one, which is en route to the Massachusetts Avenue subway station in Boston on May 29, 1950. No. 8705 was built by A.C.F. Brill, a division of the American Car and Foundry Company, which is now the nation's largest builder of railroad freight cars and specialty rail equipment.

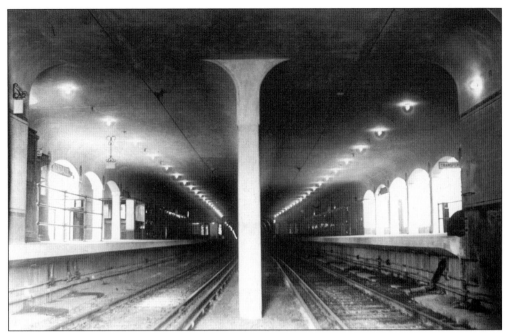

This track-level view looks into the Kendall Square subway station in March 1912, when the station was still new. Functional, with little ornamentation, it was designed to handle large numbers of people efficiently and safely with a minimum of inconvenience.

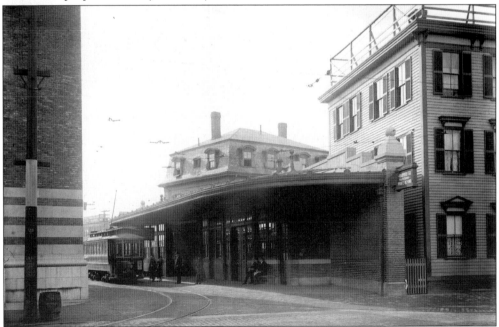

Above the subway station at Kendall Square was the transfer station for trolley cars running to various points in Cambridge, Somerville, and Boston. The trolley in this December 3, 1913 scene is about to depart for Atlantic Avenue and Rowes Wharf in Boston. The large brick structure to the left is the Kendall Square substation, which provided electric power to the subway and surface lines.

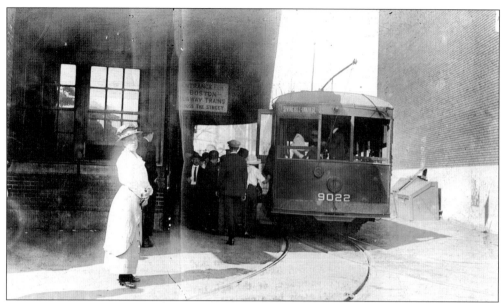

In the mid-1920s, a lightweight Birney safety car stops at the Kendall Square transfer station to pick up passengers for Inman Square and Spring Hill in Somerville. This small type of trolley car proved unsuitable for big cities like Boston, and car No. 9022 became one of a group of cars sold to Curitiba, Brazil, in 1929. Will the woman entranced by the camera miss her car?

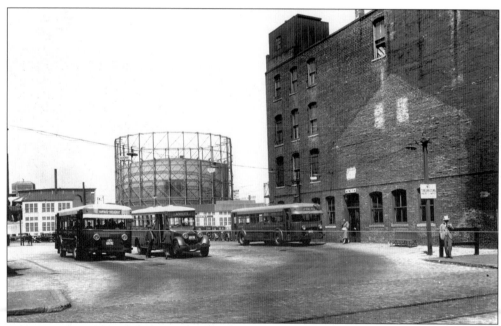

During the late 1920s, as many trolley lines in the Cambridge-Somerville area were converted to bus operation, the small trolley transfer station at Kendall Square became inadequate. The Boston Elevated Railway acquired property adjoining the original station and provided a new waiting room and large bus loading area, seen in this May 17, 1933 view. Note the large gasometer, or tank, of the Cambridge Gas Light Company in the background, once a common sight in this area.

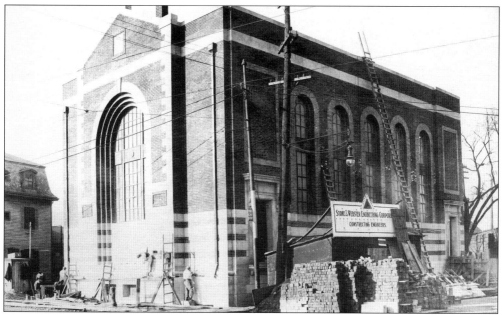

This handsome brick-and-stone structure is the Kendall Square substation, which provided electric power to the Cambridge Subway. It is shown nearing completion on October 25, 1911. The Boston Elevated generated its own power at its South Boston and Lincoln Wharf generating stations. The electricity was carried by underground transmission lines as high-voltage alternating current to substations like this one, where it was stepped down to 600 volts, direct current, for use by the subway trains.

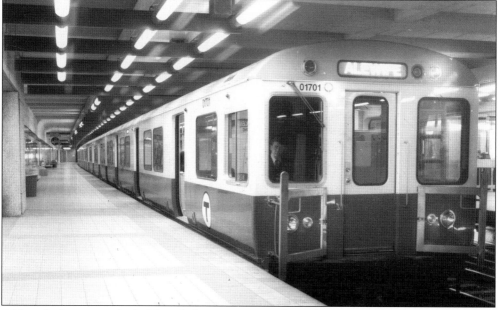

Although this station looks like it belongs to a new subway line, it is really the modernized 76-year-old Central Square station, completed in March 1988 at a cost of $11.2 million and two years of work. The new red-and-white subway cars were built by Bombardier of Canada and entered service in December 1987. William A. Bancroft would be very pleased at this scene.

CONCERNING CAMBRIDGE AND RAPID TRANSIT

SEVENTEEN DAYS of ten hours each will be saved EVERY YEAR to every person riding twice daily through the new subway.

On the surface lines the running time is TWENTY–FIVE MINUTES. Underground it is EIGHT MINUTES.

ELEVEN MILLION SEVEN HUNDRED FIFTY THOUSAND DOLLARS have been expended to accomplish this saving.

For EACH MINUTE saved SIX HUNDRED EIGHTY–EIGHT THOUSAND DOLLARS was expended.

Prior to this expenditure there were ALREADY INVESTED four million dollars in the surface lines.

FOUR MILLION DOLLARS more are being expended on the East Cambridge extension over the Charles River dam.

This will make NINETEEN MILLION SEVEN HUNDRED FIFTY THOUSAND DOLLARS the total investment for transportation to Cambridge.

The entire taxable value of all of the property in Cambridge is one hundred and twelve million dollars.

This is ONLY FIVE AND ONE–HALF TIMES greater than the street railway investment.

There are fourteen thousand one hundred and fifty dwelling-houses in Cambridge.

The street railway investment amounts to one thousand four hundred dollars for each and every such house.

No community in the world has an equal investment per inhabitant or an equal investment per dollar of wealth.

This brochure was handed out by the Boston Elevated Railway at the opening of the Cambridge Subway on March 23, 1912. It informed the riding public of the new subway's benefits and the

THE NEW SUBWAY

The Cost:

Cambridge Main Street Subway	$7,400,000.00
Terminal at Eliot Square	1,000,000.00
Cambridge Bridge with track and line equipment (prop.)	600,000.00
Beacon Hill Tunnel connection and equipment .	250,000.00
Cars and power	1,200,000.00
TOTAL EXPENDED BY BOSTON ELEVATED RAILWAY COMPANY	$10,450,000.00
Add cost of Beacon Hill Tunnel, City of Boston,	1,300,000.00
TOTAL COST OF CAMBRIDGE SUBWAY AND CONNECTIONS	$11,750,000.00

The Length:

Subway in Cambridge	11,662	Ft.
Right of way on Main Street from subway to bridge	359	"
Cambridge Bridge	2,039	"
Elevated structure from Cambridge Bridge to Beacon Hill Tunnel	678	"
Beacon Hill Tunnel	2,486	"
TOTAL	17,224	Ft., or 3.2 Miles.
Add length of subway from Harvard Square to Eliot Square	1,014	"
Add length of subway used for surface car connections	1,699	"
TOTAL	19,937	Ft., or 3.7 Miles.

(Distances between Stations:)

Harvard Square to Central Square97	Mile
Central Square to Kendall Square96	"
Kendall Square to Park Street	1.27	"
TOTAL	3.2	Miles

The Cars:

Length, 69 feet, 2⅛ inches; width, 9 feet, 6 inches; cost $12,000 each.

They represent a new departure, especially designed for rapid loading and unloading. They are much longer and wider than the cars used elsewhere for similar service, and are provided with three doors on each side; these doors so dividing the side of the car that the greatest distance from any point in the car to the nearest exit is ten feet.

Each car is provided with partitions and sliding doors, so that one end may be converted into a smoking compartment.

In service, trains will be operated of two, three, or four cars. With a two-car train the smoking compartment will be at the forward end running from Harvard Square to Park Street and on the rear end running in the opposite direction.

With a three or four car train there will be two smoking compartments, one in the forward and one in the rear car. An external sign is provided to show the location of the smoking compartment.

company's large investment to improve transportation in Cambridge and Boston.

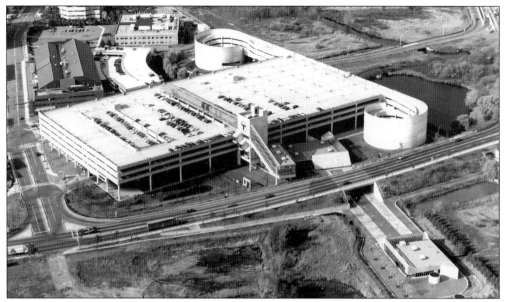

Construction began in January 1978 on the extension of the Cambridge Subway from Harvard Square to Alewife. On March 30, 1985 (seven years and $574 million later), the first train rolled into the new Alewife station, built on a former toxic-waste dump. This view, taken on November 16, 1990, shows the extent to which automobile parking provisions have increased the cost of rail transit extensions.

This view looks along the central gallery in the Alewife station. The bus loading area is in the center, with the subway trains out of sight beneath the building. Had the extension reached the originally planned terminal at Route 128, a smaller facility would have been built here at Alewife. However, the huge cost overruns of the project caused federal officials to cut off funding to complete the extension.

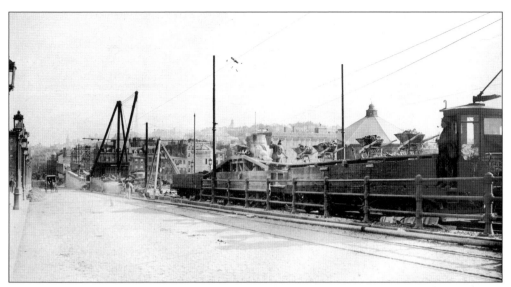

The Cambridge Subway line came to the surface at Kendall Square and crossed the Charles River on the Longfellow Bridge to Boston at Cambridge and Charles Streets. From there, it entered a new tunnel under Beacon Hill, terminating at Park Street Station beneath the existing Tremont Street Subway. In this view, looking toward Cambridge Street on the Boston side of the bridge, a trolley work train is delivering concrete to waiting workers in January 1912.

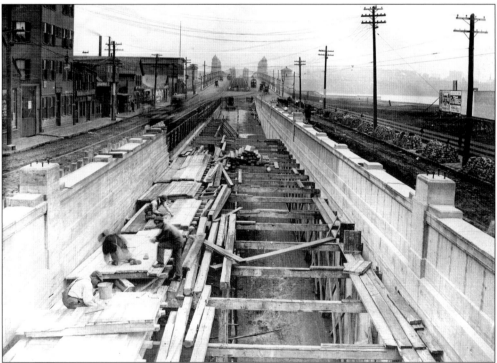

The entrance ramp of the Cambridge Subway at Kendall Square is shown in a view looking toward the Longfellow Bridge and Boston on May 11, 1911. The workmen in the center are assembling the wooden forms to hold freshly poured concrete for the tunnel ramp. The bridge is already open to trolley cars and general traffic.

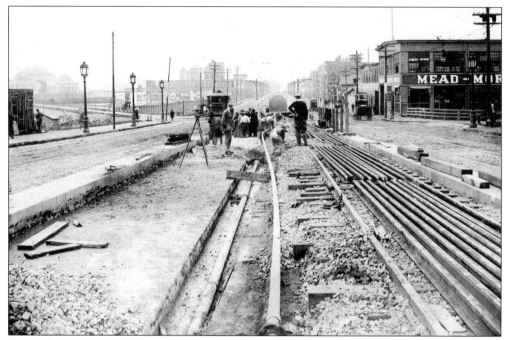

We are looking toward Kendall Square from the Cambridge end of the Longfellow Bridge, with the entrance to the Cambridge Subway visible in the center. The work is about to begin on laying the new track. All the buildings in this scene have long since vanished, and Memorial Drive is still years in the future.

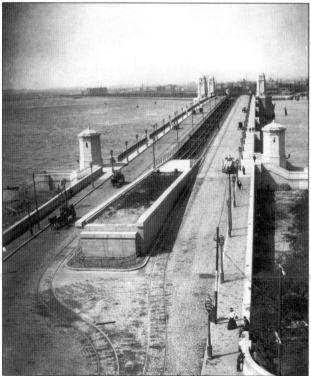

Taken on September 13, 1907, this view looks from the Boston side of the Charles River toward Cambridge. The elegant new Longfellow Bridge is already in use by trolley cars and general traffic, but it will be five more years (March 1912) before the Cambridge Subway trains begin operation over the bridge. Charles Street Station will later be built at the end of the ramp in the foreground.

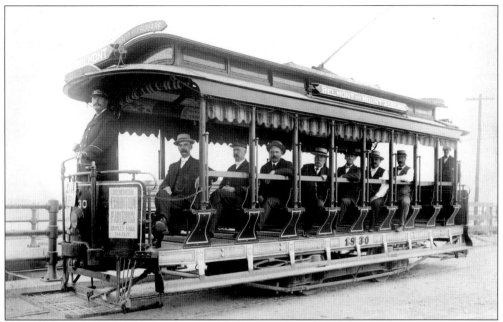

Pictured on August 8, 1906, is the first trolley car to cross from Cambridge to Boston over the new Longellow Bridge on a trial run over the newly laid track for Boston Elevated officials. Seated fourth from the left is Richard Hapgood, Boston Elevated's roadmaster in charge of all track construction and maintenance on the entire system. Hapgood had worked with William A. Bancroft on the Cambridge Horse Railroad years earlier.

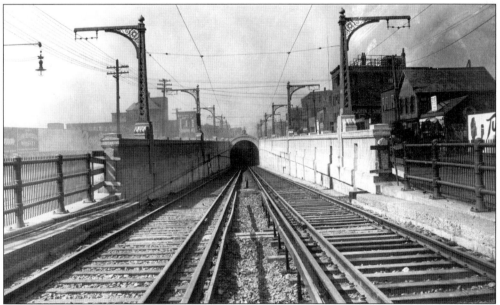

The Kendall Square entrance to the Cambridge Subway is seen here on March 20, 1912, three days before opening for service. A unique feature of the Cambridge Subway line is the use of both third-rail and overhead trolley wire, as seen here. While the third rail was used for regular train operation, it was shut off at night while maintenance trains operated from the trolley wire, making track work safer for the employees.

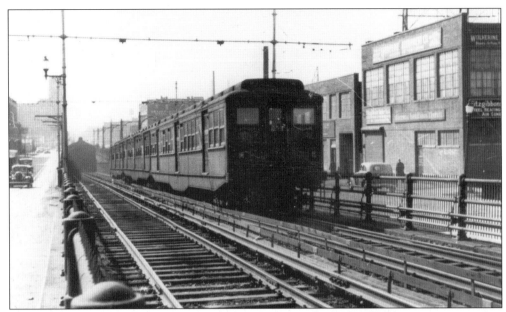

In this 1938 view, a Cambridge-bound train is rolling toward the entrance to the tunnel at Kendall Square after crossing the Longfellow Bridge from Boston. The last regular operation of trolley cars over the bridge was ended on December 14, 1925, when the line from Central Square to Bowdoin Square was discontinued.

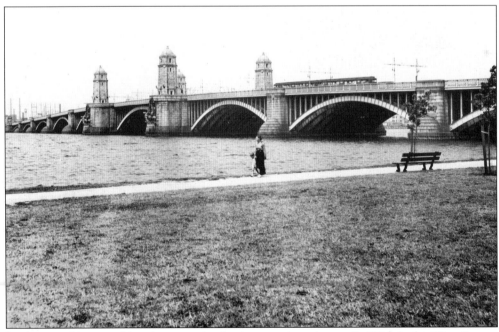

Looking as elegant and handsome as the day it opened on August 3, 1906, is the West Boston (Longfellow) Bridge. Taken in the summer of 1950 from the esplanade on the Boston side of the Charles River, this photograph shows a Cambridge Subway train heading for downtown Boston and Dorchester.

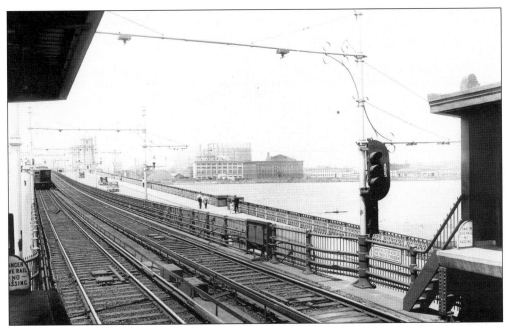

The platform of Charles Street Station affords a good view of the Longfellow Bridge, the Charles River, and Cambridge. A Boston-bound train approaches on July 18, 1933, a bright summer day. On the Cambridge side of the river are the gasworks of the Cambridge Gas Light Company. Adjoining it is the building of the Carters Ink Company, and to its right is the large Athenaeum Press building.

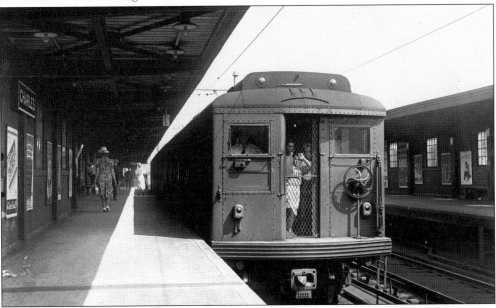

It is a warm day on August 21, 1939, as a Cambridge-bound train pauses at Charles Street Station. The front sliding door of the car is open, allowing summer breezes to circulate through the train as youngsters cluster against the safety gate, a favorite spot for young riders. Charles Street Station was opened on February 27, 1932, to serve the needs of the Massachusetts General Hospital and nearby residents.

Designed by architect H.F. Kellogg in 1932, this 14-story Art Deco office building was to have been erected over Charles Street Station as part of the project when the station was built in 1932. However, the financial famine caused by the Great Depression killed the project.

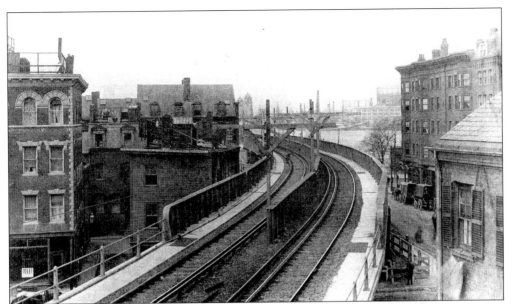

After the Cambridge Subway trains en route to the Park Street Station crossed the Longfellow Bridge, a short section of elevated structure carried them above Charles and Cambridge Streets and between brick apartment houses to the entrance of the Beacon Hill Tunnel. Some of the buildings in this early-1912 view were demolished to make way for the Charles Circle rotary.

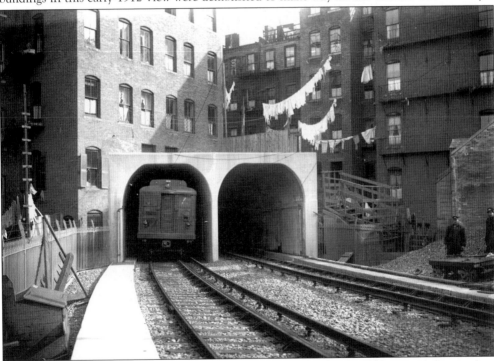

The real estate advertisements for these apartment houses doubtless pointed out their convenient nearness to the subway, certainly not an overstatement. In this view, a Cambridge-bound train roars out of the entrance to the Beacon Hill Tunnel on March 14, 1912. The buildings have their fronts on Lindall Place and Phillips Street on the lower end of Beacon Hill.

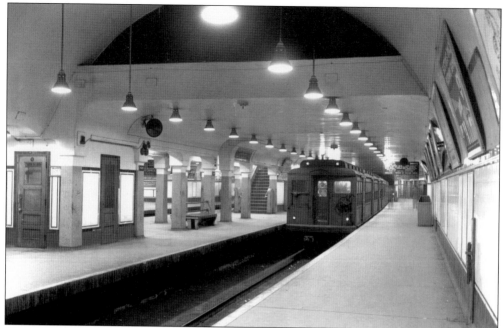

Shown on February 28, 1963, a train of old Cambridge Subway cars departs from the Park Street Under station for Ashmont in Dorchester. At locations where there were two-level subway stations, the Boston Elevated added the word *under* to the lower station. The train pictured would be retired within a few months, replaced by a fleet of new Pullman-Standard cars during the summer.

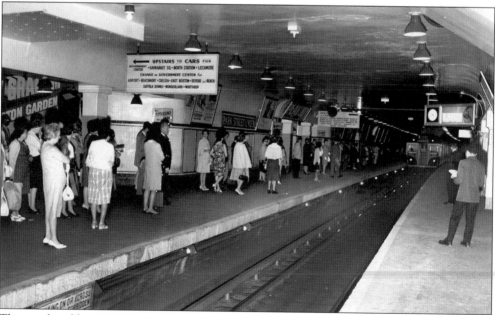

The usual midday assortment of shoppers and office workers lines the platforms at Park Street Under as a train of the new Pullman-built cars arrives, headed for Ashmont Station. Stairways on the left lead up to Park Street Station on the present Green Line, making Park Street one of the busiest transfer points on the Boston subway system.

Four

THE DORCHESTER
TUNNEL

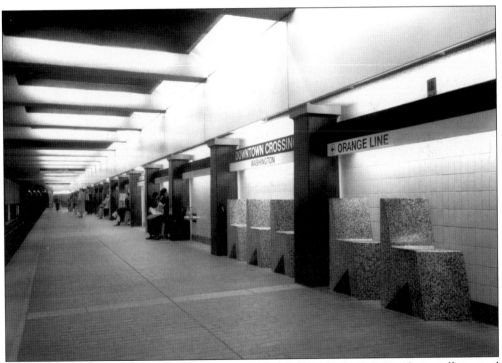

The next stop after Park Street in downtown Boston is Downtown Crossing (originally named Washington Street). Here, transfer is made to the Orange Line. Originally, the mezzanine level of this station housed an array of shops and direct entrances into the basement levels of Boston's leading department stores. Note the seats on the right, an example of designers run amuck. Officially, the Dorchester Tunnel started at Washington Street Station.

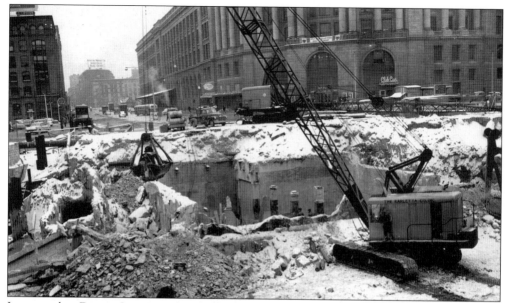

It seems that Dewey Square in front of the South Station periodically becomes a canyon for some sort of transportation project. It was dug up during 1915–1916 for the extension of the Cambridge-Dorchester Tunnel and in 1956–1957 for the tunnel portion of the John F. Fitzgerald Expressway, seen here on January 31, 1957. The square has also been targeted by the well-known Big Dig project to bury the expressway in a tunnel.

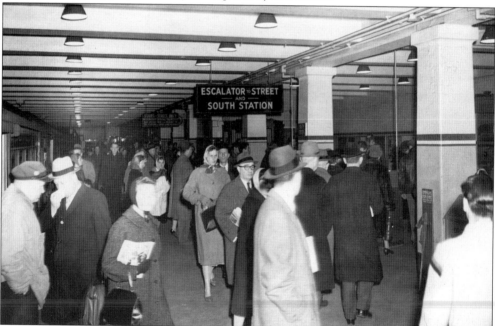

South Station has always been one of the busiest stations on Boston's subway system, as it is a destination point for scores of downtown workers as well as a transfer station for those riders arriving on commuter trains from the suburbs. This photograph, taken at 7:30 a.m. on March 24, 1960, shows that felt hats for men and bandanas for women were the popular winter headwear for that period.

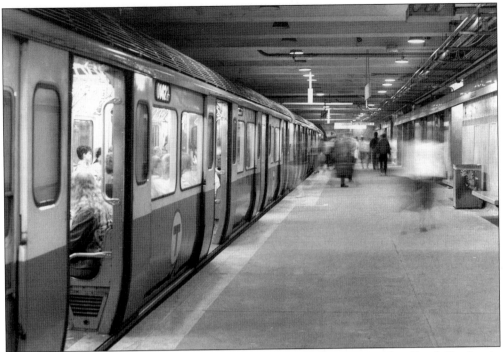

A train of 1963 Pullman-Standard cars headed for Cambridge is stopped at South Station in this 1967 view. The station appears neglected and seedy, with many lights not working, peeling paint, water leaks, and haphazard wiring hung from the ceiling. The station certainly looks all of its age of 51 years.

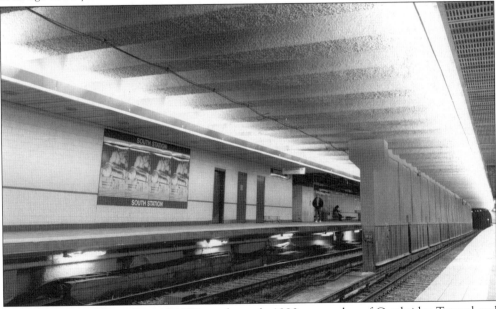

During the period from the mid-1980s to the early 1990s, a number of Cambridge Tunnel and Red Line stations received a long overdue rehabilitation and modernization, including South Station. In this 1993 photograph, modern lighting, bright new tile, and wall murals have done wonders for the station.

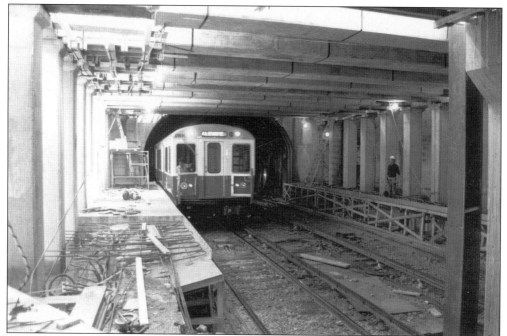

South Station was not only modernized but was also lengthened to accommodate six-car trains in place of the four-car trains in use on the Red Line, made necessary by increased riding. Many Red Line stations were given extended platforms. This view shows an Alewife-bound train passing one such project.

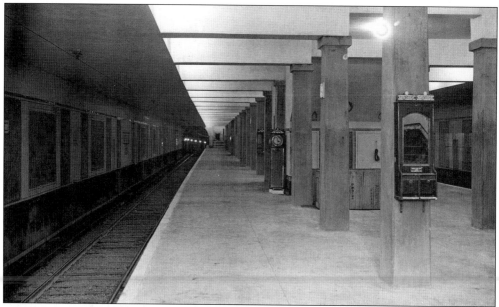

The Dorchester Tunnel opened for operation as far as Broadway in South Boston on December 15, 1917, and this view was taken two days later. Broadway Station was unique in that it had three levels—a street-level transfer station for trolley cars, a subway-level station for trolley cars, and (as shown here) a below-subway level for the Cambridge Subway trains. Note the penny candy machines and weight machines, once a common feature of Boston subway stations.

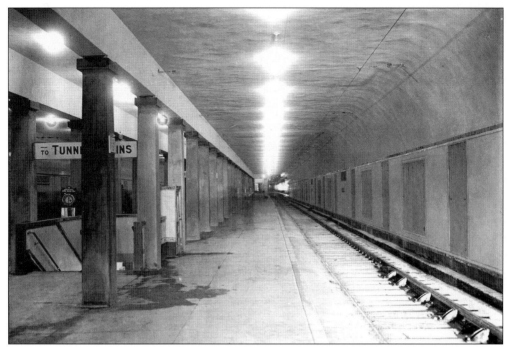

Used by trolley cars, this mid-level subway station at Broadway was in service only from December 1917 until the end of 1919, when it was rendered unnecessary by the extension to Andrew Square. Although various uses were proposed over the years for the unused station (including growing mushrooms), it became a storage vault for transit authority records and proved a gold mine for transit historians when they discovered it.

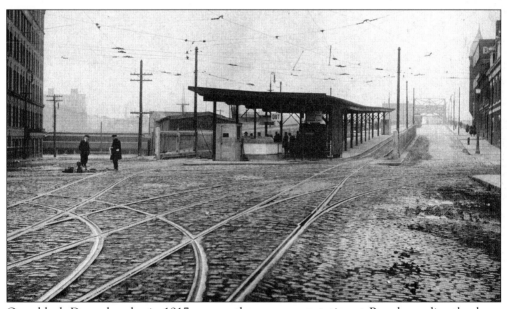

On a bleak December day in 1917, we see the uppermost station at Broadway, directly above the two subway levels. Originally open to the weather, the station was later enclosed. The Broadway swing bridge is in the background.

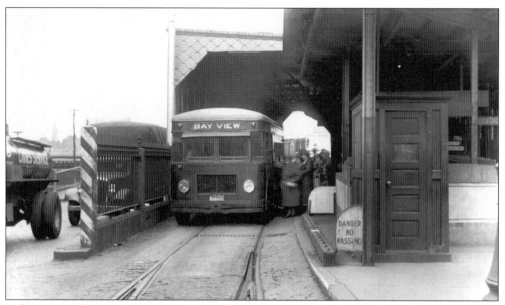

In later years, the station was used by trolley cars on the City Point–North Station line and buses on the Bay View route, one of which is seen loading passengers in this 1935 photograph. This upper-level station was removed in March 1988 and was replaced by a small sidewalk loading area nearby.

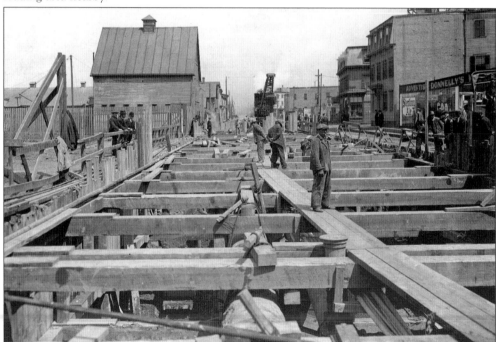

Taken on May 4, 1915, this photograph of Dorchester Avenue in South Boston looks toward Broadway. Construction of the Dorchester Tunnel to Andrew Square is under way. It was costly disruption of this sort that caused transit officials to reconsider building a subway through busy Uphams Corner and Codman Square in Dorchester and instead use the New Haven Railroad tracks to run rapid-transit trains through Dorchester to Ashmont.

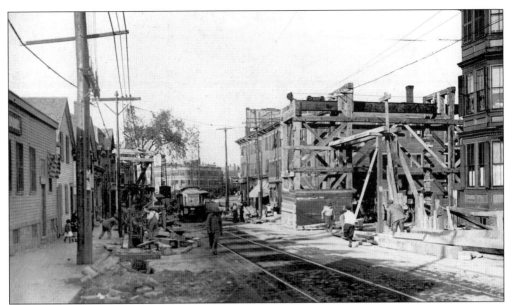

Looking toward Andrew Square on October 3, 1916, this view shows Boston Street with subway construction under way. The approaching trolley car is headed for Uphams Corner and Columbia Road after starting from downtown Boston. The riders will certainly welcome the extension of rapid-transit service to outer Dorchester.

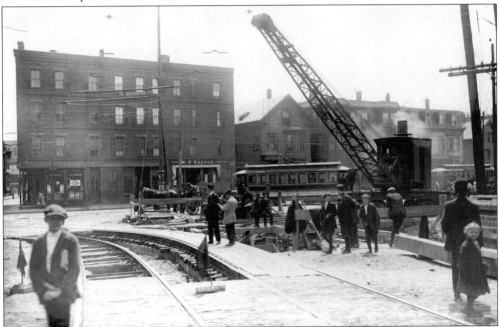

Andrew Square in South Boston is shown in a view looking from Southampton Street on May 20, 1916. The square is a hive of activity as construction is under way on the Dorchester Tunnel line. The trolley cars in the background are bound for Uphams Corner and Codman Square. The steam-powered crane to the right has attracted a school-age audience. The M. O'Keeffe grocery store, in the center, was part of a large chain of Boston stores that vanished in a merger with a larger chain.

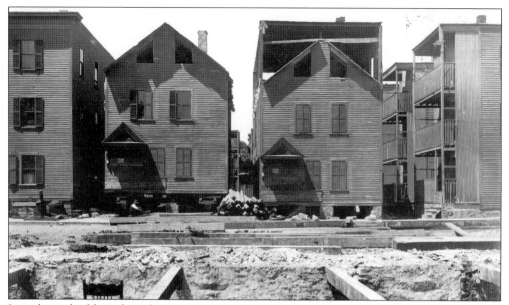

In order to build Andrew Square Station of the Dorchester Tunnel line, the Boston Transit Commission ordered 54 families and 10 stores to vacate their premises in an order issued on March 30, 1916. Many houses were moved to new locations nearby rather than being demolished. This May 23, 1916 view shows two three-decker houses being readied for moving. Oddly, these two buildings have been converted into two-family houses.

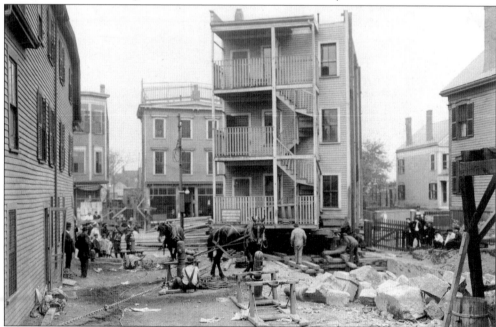

On June 5, 1916, this three-decker is being moved by workers of the John Cavanaugh & Sons Building Movers to make way for the new Andrew Square Station. Building moving was once a common practice in Boston, and the Cavanaugh firm was a recognized leader in the field. The last major building relocation to make way for a transit extension took place in 1951, when 26 dwellings were moved to new locations when the Blue Line was extended to Orient Heights.

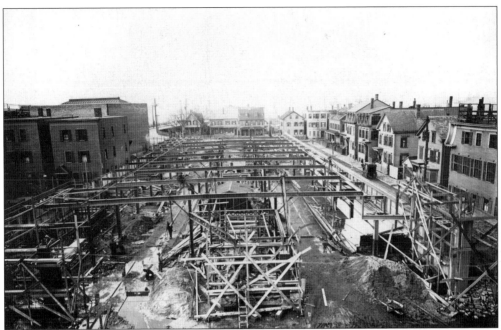

Construction is proceeding on the new Andrew Square Station on November 23, 1917, on the site of the removed three-decker houses that had been located on Dexter Street and Dexter Place. Most of the houses to the right and in the background, with their various interesting architectural styles, have survived to the present day.

The Dorchester Avenue entrance to Andrew Square Station is shown on June 11, 1959. Even after extension of the Dorchester rapid-transit line to Ashmont Station, Andrew Square remained a busy station and was completely rebuilt during the 1990–1993 period.

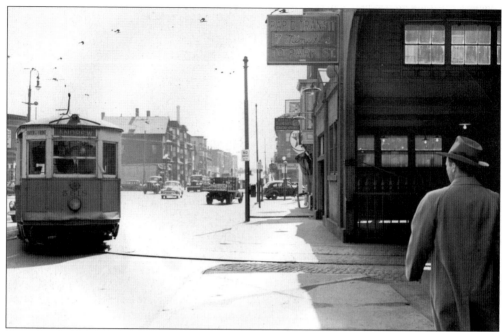

In this 1945 view, a trolley car is turning from Dorchester Avenue into Andrew Square Station. Andrew Square can be seen in the background. The sign on the station proclaims, "Rapid Transit 7 Minutes to Park St." This was a big improvement over the former 35-minute surface trolley trip through busy streets from Park Street to Andrew Square.

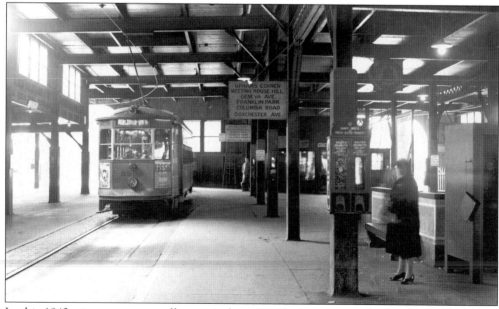

In this 1942 winter scene, a trolley car is departing Andrew Square Station for Fields Corner via Meeting House Hill and Geneva Avenue. Note the penny candy and peanut machine in the foreground. Another now vanished feature of Boston transit stations is the heated waiting room with seats, as seen in the background.

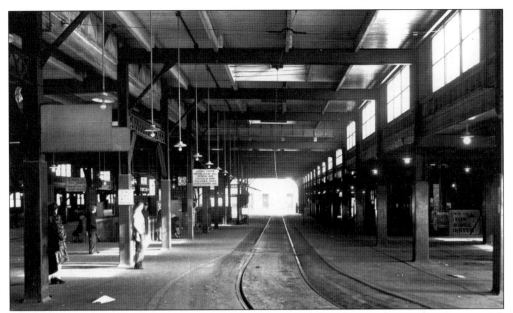

This view looks through Andrew Square Station toward Dorchester Avenue on January 24, 1947. The station provided easy, out-of-the-weather transfer to local surface lines. One could board trolley cars for Dudley Station, City Point, Fields Corner, and Franklin Park as well as buses for Savin Hill at this time, a period when Dorchester residents enjoyed good public transit.

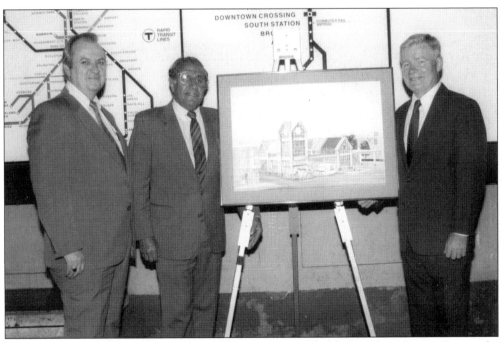

In September 1990, plans were announced at a ceremony held at Andrew Square Station for the complete rebuilding of the surface-level station along with modernization of the subway level beneath it. This photograph shows architectural plans for the new station. Standing to the right is state senate president William Bulger, who arranged the project.

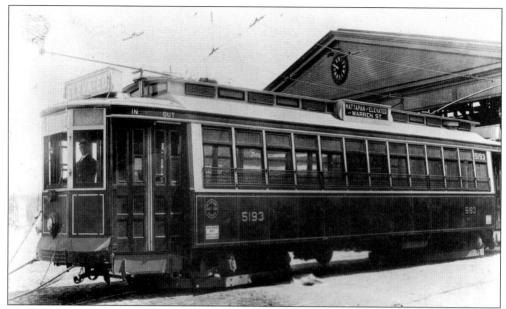

The ongoing growth of population in the Dorchester district meant increased riding on the surface trolley lines carrying local residents to the Dudley Street elevated station and Andrew Square tunnel station, both of which were becoming overcrowded. Larger trolley cars were provided to handle the crowds (such as this Type 4 car, seen at the Grove Hall car house), but demands by residents for real rapid transit continued to grow.

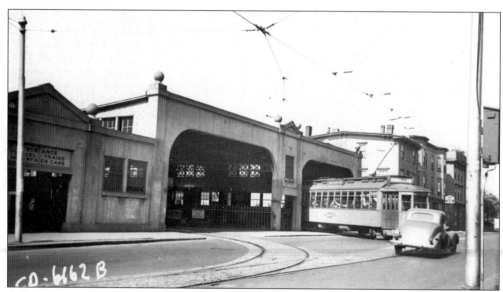

A Type 4 trolley running on the City Point–Dudley Station line enters Andrew Square Station on October 3, 1937. The scene looks rather placid compared to the conditions that existed by the early 1920s. At that time, trolley cars often blocked traffic while waiting to enter the crowded station to pick up riders—a situation remedied by the extension to Ashmont in 1928.

Five

RAPID TRANSIT
TO MATTAPAN

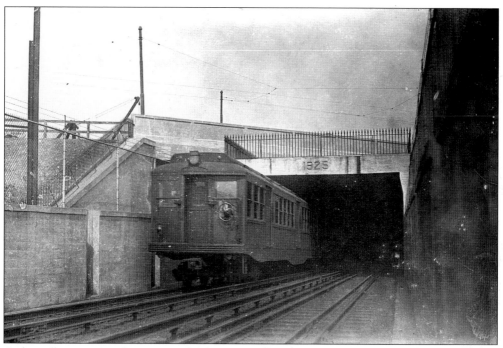

At last, there was rapid transit to Dorchester! In this October 1927 view, a train emerges from the Dorchester Tunnel while on a training trip to Fields Corner Station several days before the line opened. Prior to the construction of this line over the tracks of the New Haven Railroad to Fields Corner and Ashmont, intensive study was undertaken of several proposed subway routes through the center of Dorchester.

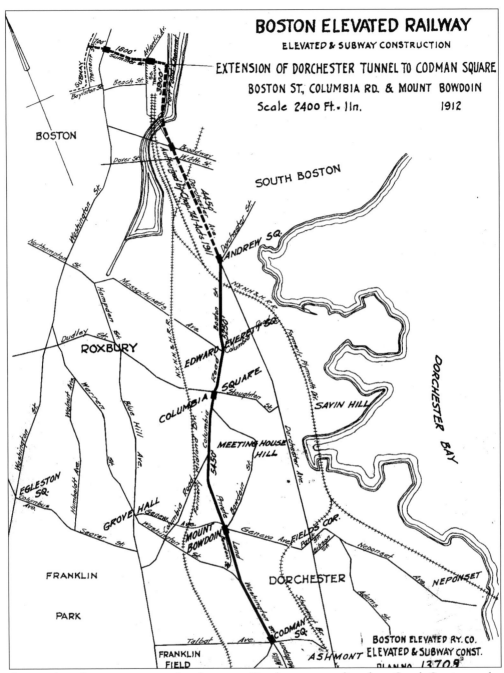

Among the subway routes considered to serve Dorchester was a line from South Station under Dorchester Avenue all the way to Ashmont and Milton Lower Mills. The preferred route, however, was through Edward Everett Square, Uphams Corner, and Mount Bowdoin, with a terminal just south of Codman Square. Pictured is one of several plans for this route, dating from 1912–1914.

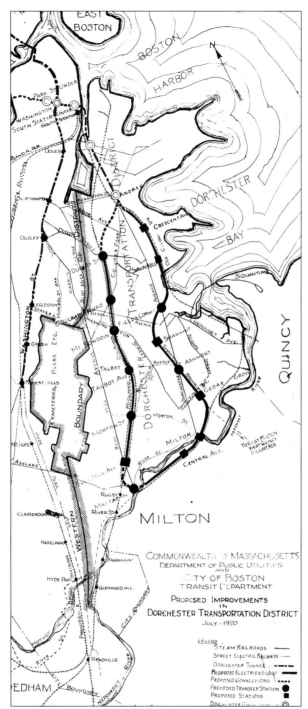

The idea of costly and disruptive subway construction under Dorchester's major streets caused transit officials to look at a practical and economical alternative to subways—the use of the New Haven Railroad tracks that cut through Dorchester over two routes. This plan from July 1920 envisioned the use of both the Midland Division and Old Colony Division tracks to provide a loop service through Mattapan from Andrew Square.

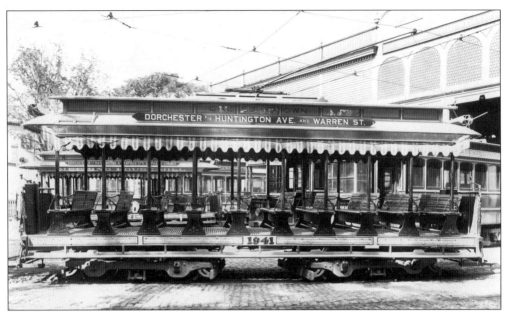

Pictured is open summer trolley No. 1941, standing at the Dorchester car house on Washington Street in June 1908. This car was one of a group of such cars built in the company's Bartlett Street car shops in 1890. Had the Dorchester subway been built through Codman Square as originally planned, this car house would have become a storage yard for rapid-transit cars. Today, the property is occupied by a YMCA and a high-rise apartment house for the elderly.

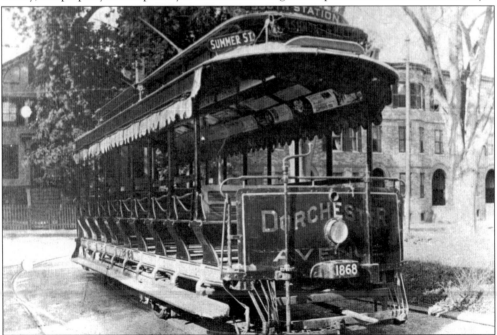

Open trolley No. 1868, painted dark blue and lettered "Dorchester Avenue," is the type of car that carried summertime commuters on the long route from South Station to Ashmont and Milton in the days before rapid transit. The car was built by J.M. Jones & Company of Troy, New York, in 1893, with the Boston Elevated owning 747 cars of this nine-bench type.

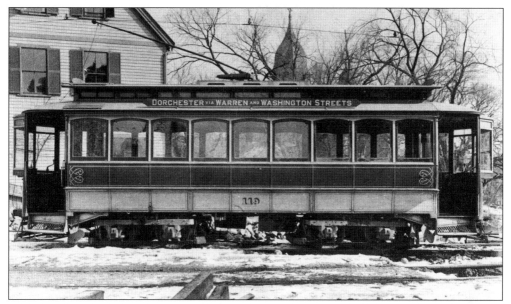

During the winter months, Dorchester riders crowded into small box-type cars, such as No. 119, seen here at the Milton Lower Mills car house on Dorchester Avenue in 1906. The elevated company at one time owned nearly 1,200 of these small, cramped cars. The last ones were retired in 1927.

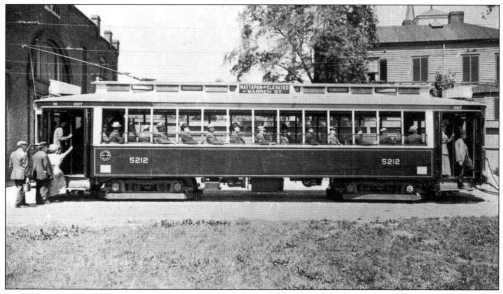

In 1911, the Boston Elevated Railway introduced the first of 275 large, fast Type 4 cars, many of which were assigned to routes serving Dorchester to replace the small and cramped box-type cars. This photograph was taken in May 1911 at the Bartlett Street car shop. The view illustrates the new method of entering at the rear of the car, paying the fare to a seated conductor, and exiting at the front. This method greatly sped up service.

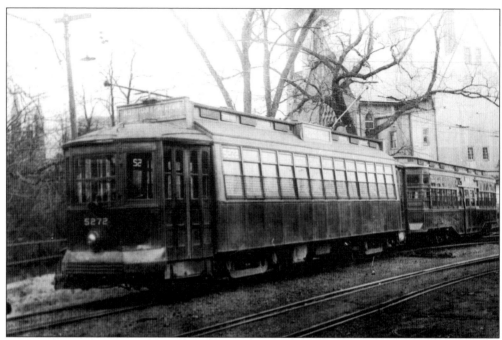

Pictured at the Milton car house, located on Dorchester Avenue at Milton Lower Mills, is Type 4 car No. 5272. It is hauling trailer car No. 7193 and is awaiting departure time for the long ride down Dorchester Avenue to Andrew Square. Passenger loads had so increased by 1916 that it became necessary to run these two car trains on the routes from Andrew Square to Neponset and Milton.

A motor and trailer train is seen here at the Fields Corner car house in 1926. It is about to leave for a trip on the Andrew Square–Neponset line. In about a year, the new rapid-transit extension would be opened as far as Fields Corner, finally eliminating the long lines of streetcars moving along Dorchester Avenue.

Shown at Neponset Station in 1925, Type 4 car No. 5447 is about to loop around the station for its return trip along Neponset and Dorchester Avenues to the Andrew Square Tunnel station. In the background is the Minot School. When the South Shore branch of the Red Line opened to Quincy in September 1971, the requests by residents for a station at Neponset was refused.

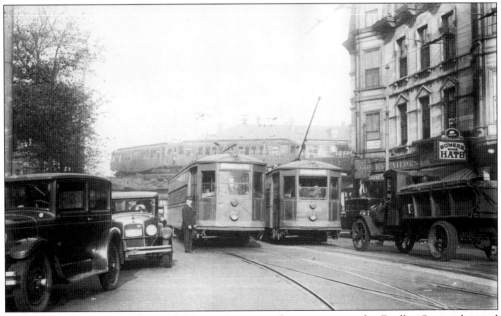

This 1926 scene is at Dudley and Warren Streets at the entrance to the Dudley Street elevated station, where an elevated train is entering the station. The Boston Elevated Railway claimed that this was the busiest trolley junction on the system and that the opening of the Dorchester rapid-transit line would relieve congestion at this point, since many of the trolleys would be rerouted to the new line's stations.

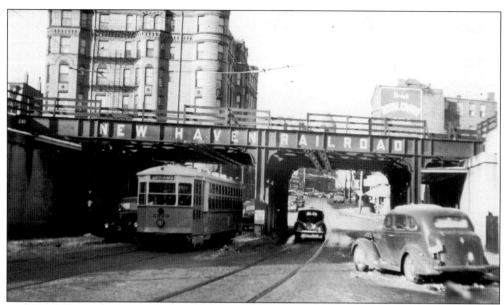

Freshly painted Type 5 trolley No. 5929 is on Dudley Street, heading for Uphams Corner, and is passing under the Midland Division railroad line in December 1948. Had the Dorchester rapid-transit loop been completed as planned, subway trains from Mattapan would have used this bridge, stopping at a station just out of sight to the right.

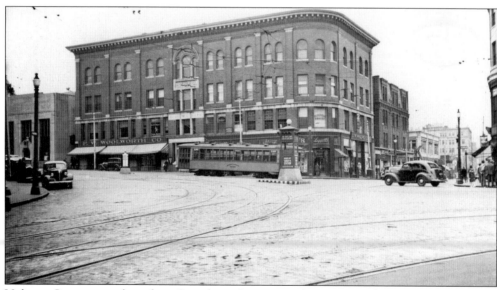

Uphams Corner, seen here from Stoughton Street, is rather quiet in this May 19, 1938 view. Had the Dorchester subway to Codman Square been built, a station would have been built under this normally busy square. The Upham Building is behind the trolley car, housing two old-line retail firms in its first floor, an F.W. Woolworth and Liggett Rexall Drugs.

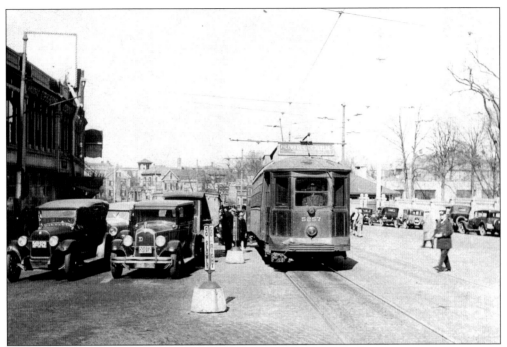

We are looking down Columbia Road from Uphams Corner in this 1927 view. The big Uphams Corner Market (one of Boston's first supermarkets) is to the left, and the historic old Dorchester Burial Ground is to the right. The planned subway to Codman Square would have been located under Columbia Road through here. Trolley No. 5257 is headed for Fields Corner via Meeting House Hill.

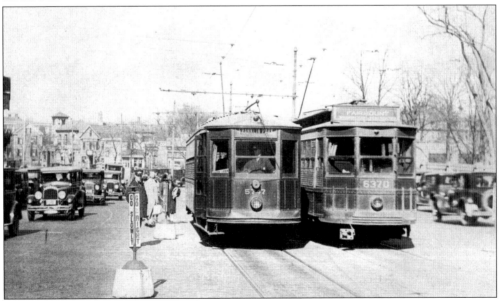

The Boston Elevated reported that trolley car traffic through Uphams Corner was about the heaviest among the numerous such junctions on the system, with 976 cars passing through here between 8:00 a.m. and 6:00 p.m. on May 26, 1926. It was pointed out that the new Dorchester rapid-transit line would greatly reduce the trolley traffic through Uphams Corner, as seen here.

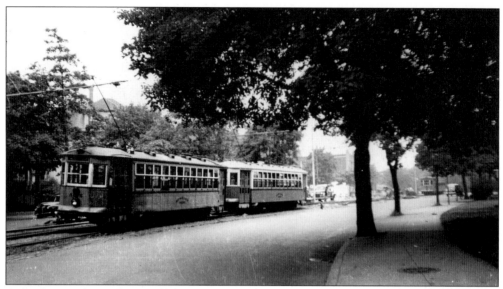

Columbia Road, seen here with several trolleys bound for Franklin Park in the summer of 1943, escaped the trauma of subway construction in the 1920s only to be destroyed in the early 1950s. The lovely boulevard, with a center reservation and three rows of large shade trees, was converted into a highway with a concrete center island, high-intensity lighting, and heavy motor traffic, causing residents to flee.

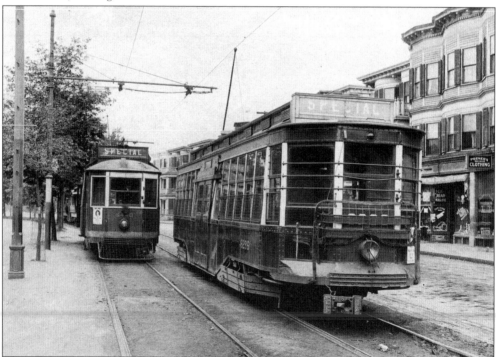

The Dorchester subway would have had a station at Edward Everett Square, seen in a view looking up Columbia Road toward Uphams Corner in 1921. Type 4 trolley No. 5440 and center-entrance car No. 6286 typify the large cars required to handle the heavy riding to Andrew Square Tunnel station.

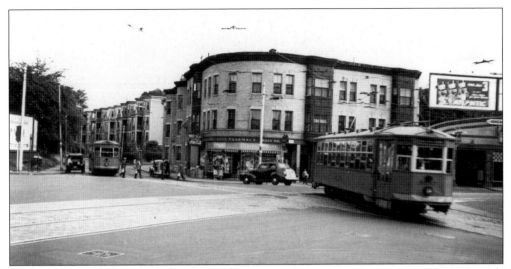

This view shows the corner of Bowdoin Street and Geneva Avenue on June 20, 1939, with several trolleys passing through the intersection. This would have been the site of the Mount Bowdoin station of the proposed Dorchester subway line. A gravel pit to the left of this view would have become a transfer station.

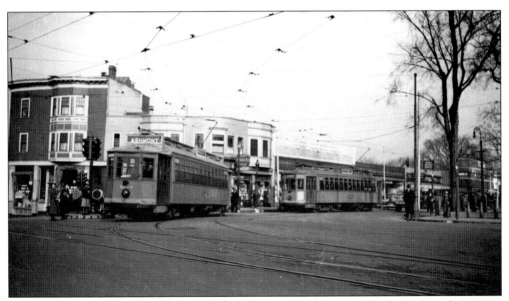

Looking across Codman Square from Talbot Avenue to Washington Street on March 8, 1939, we see two trolleys and a bus bound for Ashmont Station. Codman Square would have been the terminal point for the Dorchester subway, with the station located beneath the square.

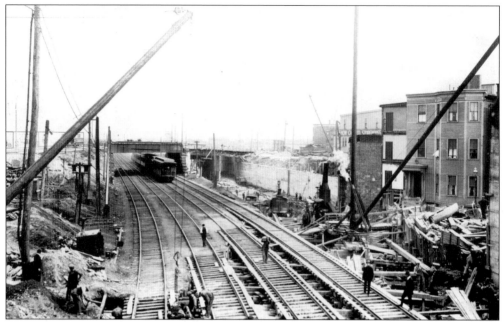

Looking from the Boston Street Bridge on June 1, 1925, this view shows work starting on the Dorchester rapid-transit loop to Mattapan over the Old Colony Division of the New Haven Railroad. The steam-powered commuter train is passing under the Dorchester Avenue bridge. Note how a section of the three-decker house at right has been neatly amputated.

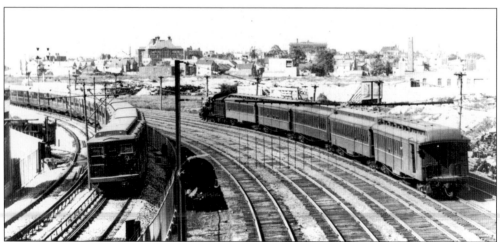

The old and the new are seen in this October 1, 1927 view, looking northward from the site of the present JFK-UMass Station. As a commuter train of wooden coaches from the South Shore heads into Boston, a line of new Type 4 Cambridge Tunnel cars sits on the new Dorchester rapid-transit line, awaiting the opening of the line on November 5. The large building dominating the background is the John A. Andrew School.

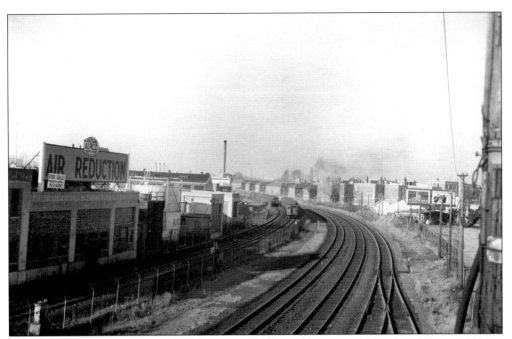

Here is the same location on December 6, 1960, with two Dorchester rapid-transit trains passing by the now vanished AIRCO compressed-gas plant. To the right is one of South Boston's first public housing developments.

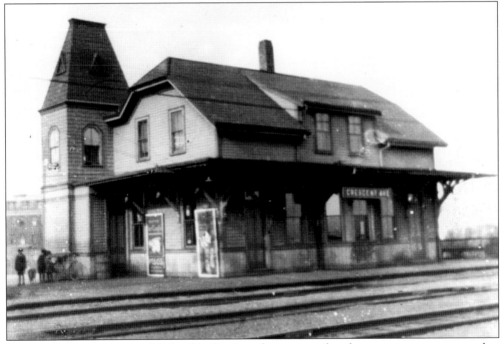

Prior to the construction of Columbia Station, the steam railroad commuter trains stopped at the Crescent Avenue station, seen here in 1925. This station was built in 1883, replacing an earlier building dating from 1869, both built by the Old Colony line. This station was torn down in the fall of 1927.

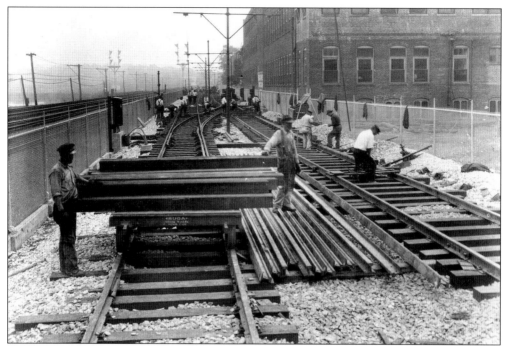

This view looks southward at Crescent Avenue on the new Dorchester rapid-transit line on June 20, 1927. A track gang is hard at work in an era when there were few power tools except for some pneumatic track tampers. Sledge hammers, lining bars, and large wrenches powered by human muscle were the commonly employed tools.

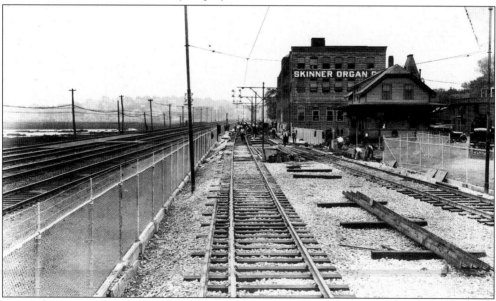

The new Columbia Station is out of sight behind us as we look south on the Dorchester rapid-transit line. The former Old Colony Crescent Avenue station, just recently closed, is seen on the right, with the large factory of the Skinner organ works just beyond. The Southeast Expressway now crosses the Red Line at this point. When the expressway was built in the 1950s, this end of the organ works was removed.

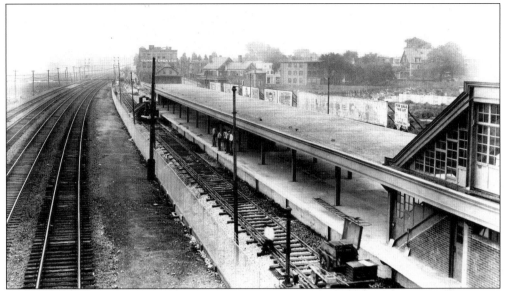

August 1, 1927, finds the new Columbia Station (now called the JFK-UMass) virtually complete with the soon-to-be-demolished Crescent Avenue railroad station just beyond. As a result of poor planning in the mid-1960s, two more stations have been built in this area.

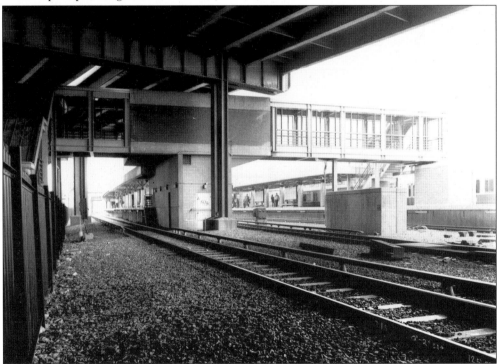

Looking northward from under the Southeast Expressway on December 15, 1988, we see the original Columbia Station to the left. To the right is the adjoining JFK-UMass Station, having just opened to serve the South Shore trains. When the Old Colony commuter rail service was restored in December 1997, yet a third station was opened next to these two at the insistence of commuters.

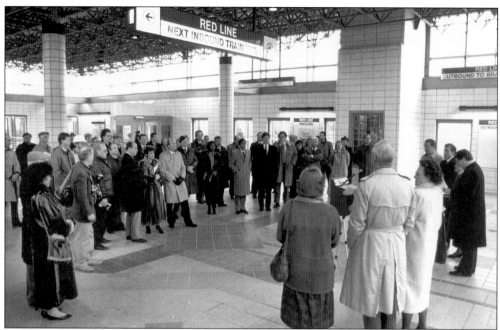

In 1971, when the South Shore branch of the Red Line was opened, the trains bypassed the increasingly busy JFK-UMass Station, ignoring the persistent requests of commuters. Finally, the Massachusetts Bay Transit Authority admitted its error. At a cost of $13.5 million, the authority opened the second JFK-UMass Station in a ceremony seen here on December 14, 1988. Again, in 1997, authority officials refused to provide a station here on the restored Old Colony commuter line but, in 2001, provided a third station.

On June 27, 1923, we see the Savin Hill Avenue bridge in the background, with the southbound brick Savin Hill railroad station on the left. The northbound station, partly visible to the right, was of wooden construction. A fence separates the express tracks in the center, since express trains did not make stops in Dorchester (their first stop being in Quincy).

Here is the same view on August 25, 1927, with the quaint brick railroad station just a memory. The new Savin Hill rapid-transit station is almost completed, and the Old Colony Division tracks have been shifted to the right to provide room for the new rapid-transit tracks about to be laid.

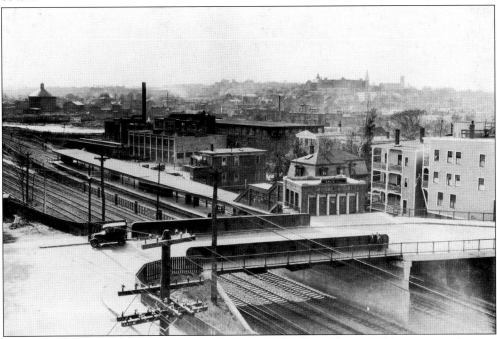

This interesting panoramic view of the new Savin Hill rapid-transit station was taken on October 27, 1927, several days before rapid-transit service began. The odd round building to the left is a former gasworks. In the distance is Meeting House Hill. On the hill are, from left to right, the Edward Southworth and Mather schools, the First Church of Dorchester, and St. Peter's Church.

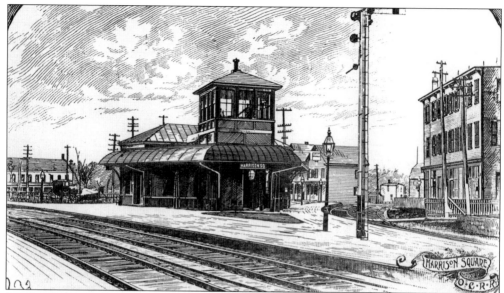

South of Savin Hill is Harrison Square, which once had its own railroad station, originally called Dorchester. In this mid-1870s view, the Old Colony tracks to Quincy and Braintree bend to the left. The Shawmut Branch tracks to Ashmont and Mattapan curve to the right. Note the signal tower atop the station building.

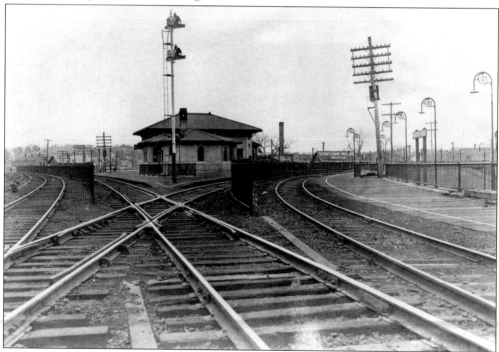

This view shows Harrison Square station on March 25, 1924. Many changes have taken place; most notably, the rights-of-way of both the Old Colony Division and the Shawmut Branch were raised in 1911–1912, eliminating most grade crossings through Dorchester. The Spanish Mission–style station was built in 1911. The Old Colony line, curving to the left, now has four tracks, a major improvement.

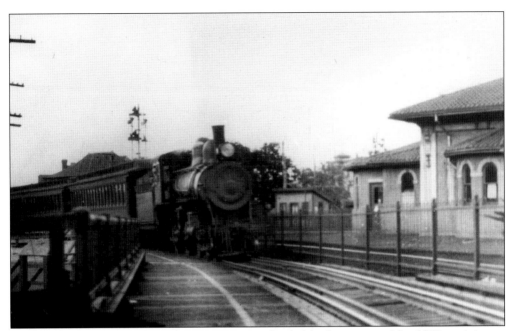

Here is the last steam-powered commuter train hauled by locomotive No. 1558, arriving at Harrison Square and bound for Ashmont and Mattapan via the Shawmut Branch. Although train service to Mattapan via Neponset continued a while longer, the Shawmut Branch section through Fields Corner and Ashmont underwent conversion to rapid-transit operation.

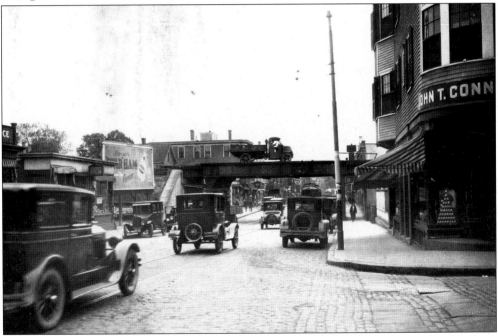

We are looking south on Dorchester Avenue just below Fields Corner on September 27, 1926, as a contractor's dump truck drives over the Shawmut Branch railroad bridge, which will soon see rapid-transit operation. In the distance, three trolley cars are making their way up Dorchester Avenue to Ashmont and Milton.

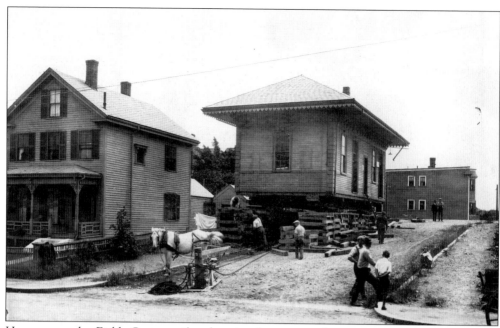

Here we see the Fields Corner railroad station being moved to a temporary site for use as a construction field office on September 7, 1926, as work proceeds on conversion of the Shawmut Branch to rapid-transit operation. This station was built in 1872 as part of the Shawmut Branch, which extended from Harrison Square to Milton Lower Mills and contributed to Dorchester's residential development.

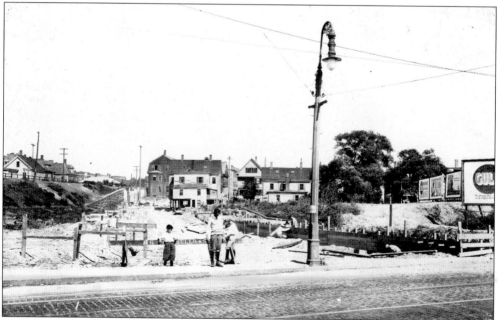

On September 14, 1926, we are looking toward the site of the soon-to-be-built Fields Corner rapid-transit station, with the railroad embankment to the left. In the center, several houses are being torn down. A new bus garage will soon occupy the area to the right. Notice the once fashionable knickers worn by the boys in the center.

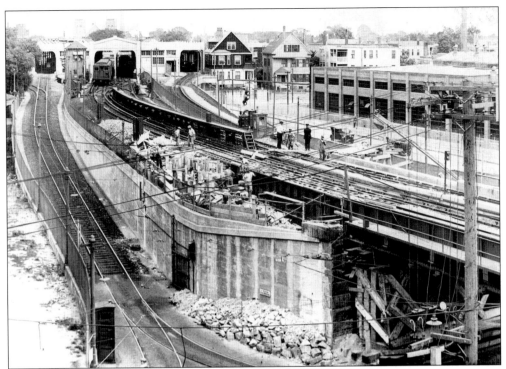

Rapid-transit trains are already operating into the new Fields Corner Station, seen here on August 22, 1928, and will soon be operating through to Ashmont on September 1, 1928. The new Dorchester bus garage to the right has just been completed. Alterations continue on the Geneva Avenue bridge, which will carry the trains to Ashmont.

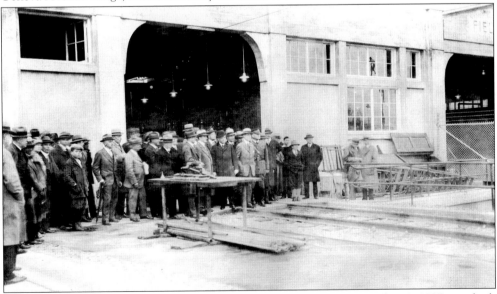

The official opening of the Fields Corner Station took place on November 4, 1927, at which time a dedication ceremony (seen here) was held in front of the station. Attending were Boston city officials, the Boston Transit Department, and the Boston Elevated Railway. Boston mayor Malcom Nichols is at the center, wearing the black derby.

Inspecting the new Fields Corner Station on October 27, 1927, is Ernest Springer (right), chief engineer of the Boston Transit Department, playing host to his two predecessors in the position of chief engineer. Howard A. Carson, who held the position from 1894 to 1909, is on the left with Edmund S. Davis, who served from 1909 to 1920. These competent gentlemen gave Boston a well-designed subway system without the need for hordes of consultants.

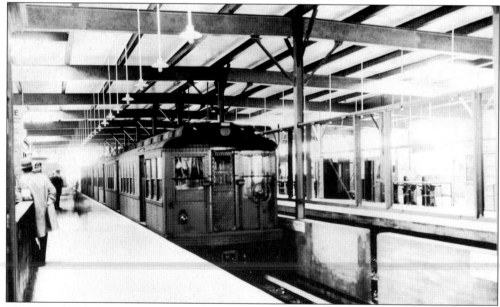

The upper level of the new Fields Corner Station is pictured on November 4, 1927, with a train just arrived from Andrew Square Station. Trolley cars and, later, buses ascended ramps to the upper level of the station, enabling quick and convenient across-the-platform transfer without the use of stairs or escalators, a feature lacking in Boston's newest transit stations.

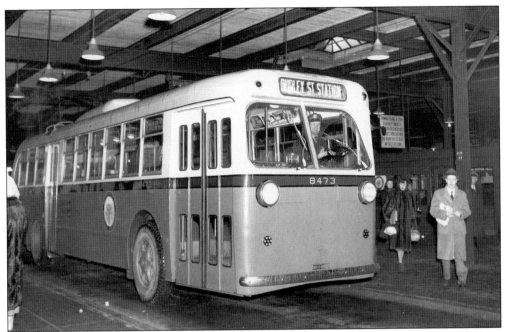

In this 1949 view, a train has just arrived from downtown Boston at the Fields Corner Station and passengers are walking across the platform to board a new electric trolley bus for Geneva Avenue and Dudley Street Station. Convenient, sheltered transfer was a longtime feature of Boston transit stations.

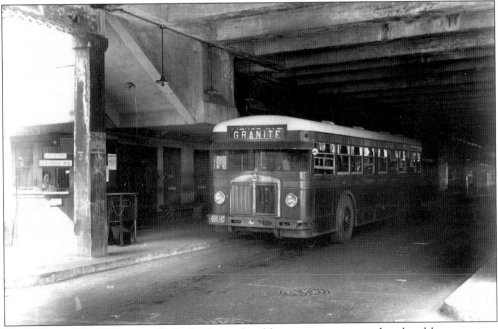

Fields Corner Station originally had a lower-level busway to accommodate local buses on two routes. In 1948, alterations to the station permitted buses to use the more convenient upper level of the station, and the lower level of the station was later closed. Bus No. 705, bound for Granite Avenue, is a 1932 product of the Mack Motor Company, a onetime major bus builder.

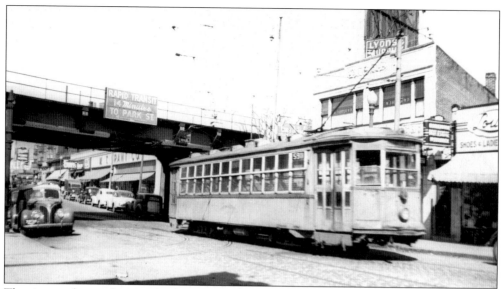

The sign on the rapid-transit bridge over Dorchester Avenue reads, "Rapid Transit 17 Minutes to Park St." The trolley seen here is about to turn into Fields Corner rapid-transit station, where passengers will board a train for a fast ride to downtown Boston in place of the former 40-minute trolley ride down Dorchester Avenue to Andrew Square Station.

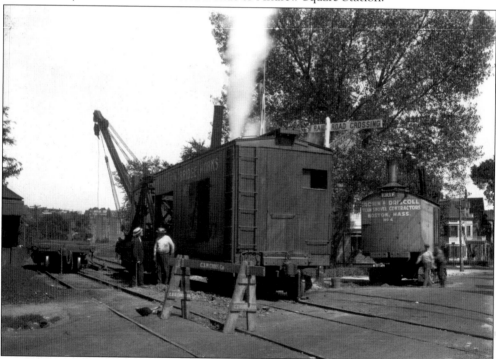

The section of the Shawmut Branch from Geneva Avenue to Ashmont was mostly at grade level and would have to be placed in a subway to eliminate the grade crossings, such as this one at Park Street, seen on September 15, 1926. Steam rather than diesel power was still important in construction work. The steam crane car to the left is removing rails while the steam shovel to the right waits to start work.

This bucolic view, taken on June 25, 1923, shows the grade crossing of the Shawmut Branch with Mather Street. In the days before automatic crossing gates and warning lights, the crossing tender (seen here in his suspenders and summer straw hat) ensured safety at rail crossings, manually lowering the gates and stopping all traffic on the approach of a train.

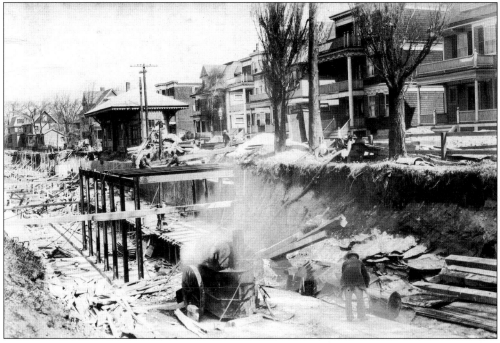

Dating from 1872, the Shawmut railroad station between Fields Corner and Ashmont is seen here on April 29, 1927, as work proceeds on the new subway station that will replace it. The steaming machine in the center is a tar-heating kettle, now rarely seen. Fortunately, all the attractive houses in the background have survived.

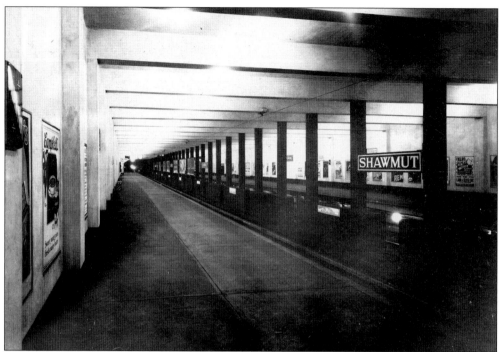

On January 2, 1929, we see the new Shawmut subway station, which replaced the picturesque country-style railroad station that had served the Shawmut Branch commuter trains for more than 50 years. In 1884, the Shawmut station replaced two earlier stations located nearby—Melvilles and Centre, which had opened in 1872.

The original 1872 Ashmont Station was located in Peabody Square at the junction of Talbot and Dorchester Avenues and was replaced in 1894 by this quaint stone station, located on the site of the present Red Line station. The land for this station was donated by the nearby All Saints Episcopal Church.

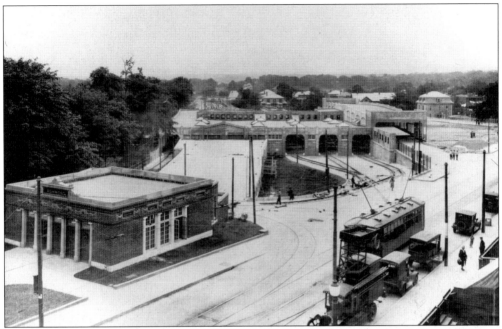

The big multimodal Ashmont transfer station that replaced the 1894 station is pictured on August 24, 1928, just prior to its opening on September 1, 1928. This well-designed terminal accommodated subway trains, trolley cars, and buses under one roof, providing easy and convenient transfer for riders.

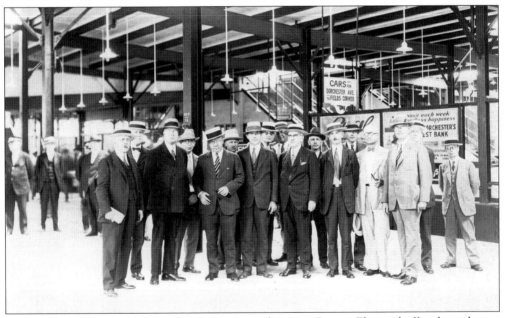

August 31, 1928, was a notable day for Boston politicians, Boston Elevated officials, and most of all for Dorchester transit riders whose long wait for rapid transit through Dorchester was about to end. Pictured are all the notables and would-be notables lead by Boston mayor Malcom E. Nichols (wearing the striped tie), inspecting the new Ashmont Station that will open to the public on the following day.

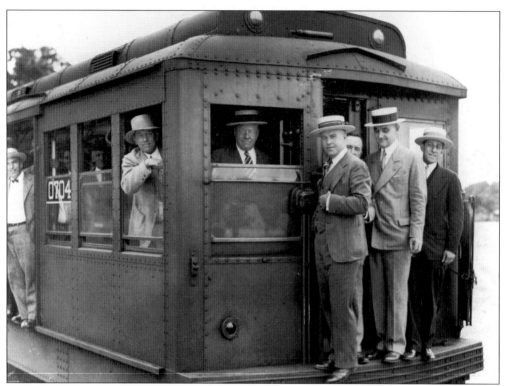

Straw hats were in style for well-dressed men on August 31, 1928, when this inspection train carried officials out to Ashmont on the new Dorchester rapid-transit extension. Boston Elevated general manager Edward Dana is leaning out the train window, and Boston mayor Malcom E. Nichols is at the train controls. Judging from that smile, maybe he got to run the train.

Ashmont Station was originally enclosed with an upper-level busway to serve local Dorchester and South Shore buses, as seen here on August 18, 1961, with buses departing for Norfolk Street and River Street. In a modernization of this station in 1981, the upper-level busway, the heated waiting rooms, and one entire wall of the station facing Dorchester Avenue were removed, exposing riders to the brisk New England winter weather.

A trolley from Mattapan is arriving at Ashmont Station just as a train for Boston is pulling into the station, assuring a rush by the trolley passengers across the platform and through the turnstyles before the train doors slide closed on November 2, 1951.

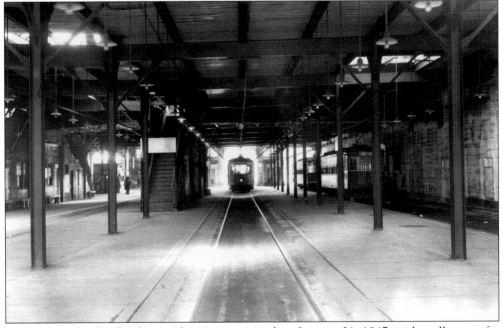

The outbound side of Ashmont Station is pictured on January 21, 1947, with trolley cars for Codman Square and Dudley Street Station waiting to depart. During the 1981 modernization, the heated waiting rooms on the left and the entire wall on the right were removed, undoing the work of the original designers.

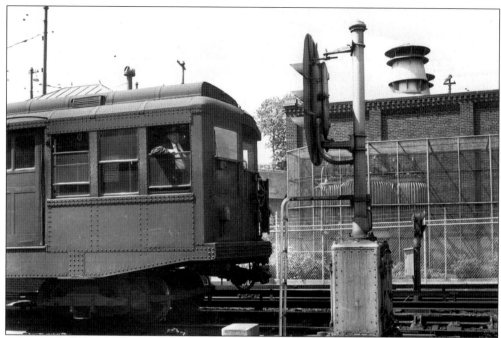

Here at Ashmont Station on August 8, 1950, we see three components of a well-run, safe, and efficient rapid-transit system, including a rugged, easy-to-maintain subway car, a well-trained operator, and a proven fail-safe signal system. These features, supervised by an experienced and competent management, made the Boston Elevated a leader in its field.

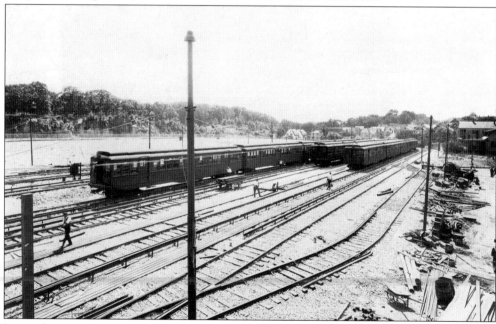

Located just south of Ashmont Station on Codman Street (now called Gallivan Boulevard) is the Codman train storage yard, seen here nearing completion on August 14, 1928. Space was provided here for a car repair shop to be built sometime in the future, but attempts to do so in the 1970s were given up due to local opposition.

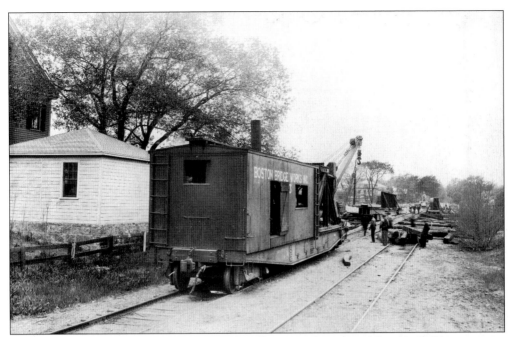

This view looks from Cedar Grove toward Gallivan Boulevard on May 19, 1927, as a steam crane car of the Boston Bridge Works prepares to set in place the girders for the new bridge over Gallivan Boulevard. The bridge would carry both the trolley cars from Mattapan and the subway trains from Codman Yard into Ashmont Station.

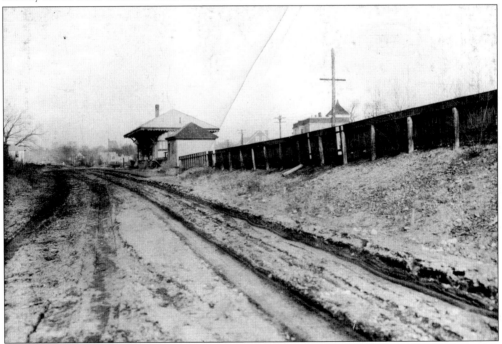

The last passenger train stopped here at Cedar Grove Station on September 4, 1926. In this December 23, 1927 view, the tracks have been removed. The station is serving as a tool house for workers converting this section of the Shawmut Branch into a trolley line.

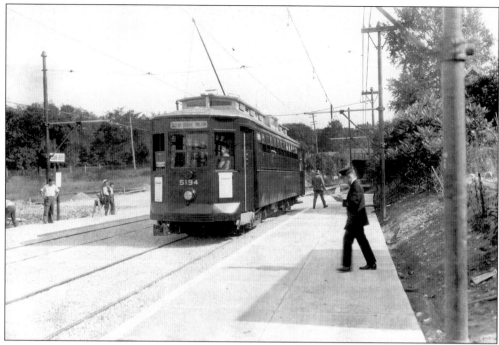

Commuter train service from Boston to Milton and Mattapan by way of Neponset ended on August 24, 1929. Trolley service was inaugurated from Ashmont as far as Milton on August 26, 1929, pending completion of conversion work between Milton and Mattapan. In this view, taken on the first day of trolley service, a freshly painted Type 4 car (No. 5194) stops at Cedar Grove Station under the watchful eye of a Boston Elevated supervisor.

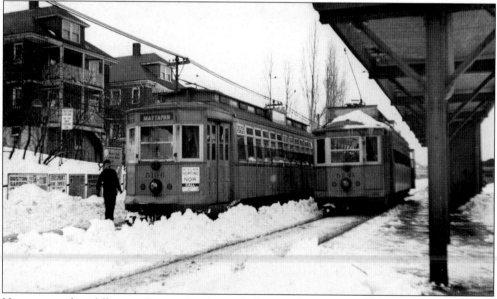

Heavy snow has fallen on Boston but has not disrupted service on the Mattapan–Ashmont trolley line, where two Type 4 trolleys are stopping at Cedar Grove Station on the morning of February 16, 1940. The large Type 4 cars performed extremely well in heavy snow and served Boston transit riders dependably from 1911 to 1952.

This two-car train from Mattapan to Ashmont is crossing the New Haven Railroad's Milton freight branch and is about to roll through the middle of the Cedar Grove Cemetery before stopping at Cedar Grove Station. The Mattapan–Ashmont line is claimed to be the only rail line in the United States to pass directly through the middle of a cemetery, a unique if dubious distinction.

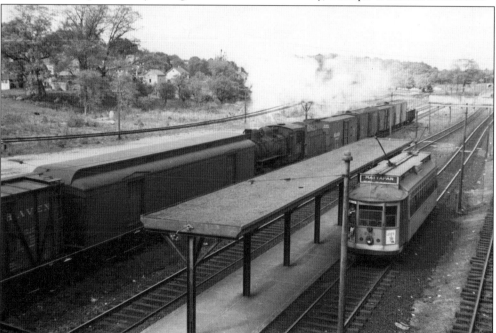

For many years after conversion of the Mattapan line from commuter to trolley car operation in 1929, the New Haven Railroad continued to provide freight service as far as Milton Lower Mills to serve several industries located there, including the famous Walter Baker Chocolate Company. Shown on May 21, 1938, a Type 4 trolley passes a steam-powered local freight train at Butler Street Station.

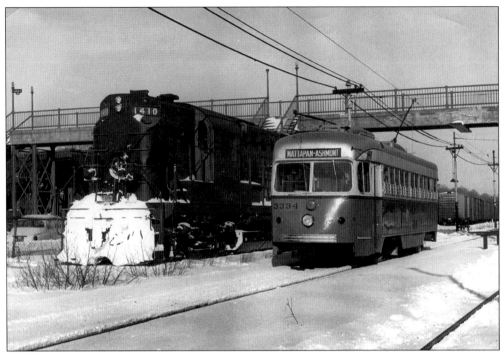

This photograph of Butler Street Station was taken in January 1962, more than 20 years later than the previous view. There have been changes, at least in railway operations. Steam locomotives have been replaced by diesels like New Haven locomotive No. 1410, which is being passed by modern PCC trolley No. 3334, obtained secondhand from Dallas, Texas, in 1959.

Smoke is drifting from the chimney of the Milton railroad station, indicating a warm waiting room on a chilly April 18, 1929. The original Milton station was called Milton Mills, becoming Milton Lower Mills by 1871. At the request of the residents of the town, it was changed to the more dignified Milton by February 1885. This station was torn down in May 1929.

Here is the Milton station area on July 3, 1929, with trackwork for the Mattapan trolley line well under way. Trolley No. 5071 (center) is a former passenger car converted to an air-compressor car to power pneumatic track tools. The Godfrey Coal Company is to the left, and the ivy-covered building to the right is part of the Baker Chocolate Mills—both longtime Milton landmarks.

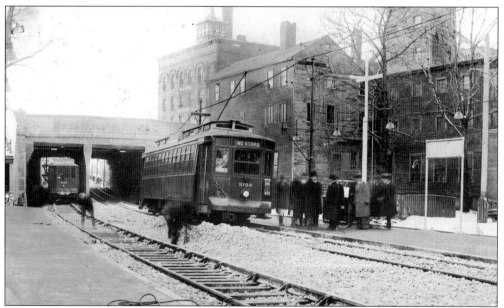

Trolley service beyond Milton to Mattapan began on December 21, 1929. This view, taken a few days before the opening, shows Boston Elevated officials stopping their special trolley at Milton Station to inspect progress. The large brick structure beyond the Adams Street bridge is the Webb Mill, part of the Walter Baker Chocolate Company complex.

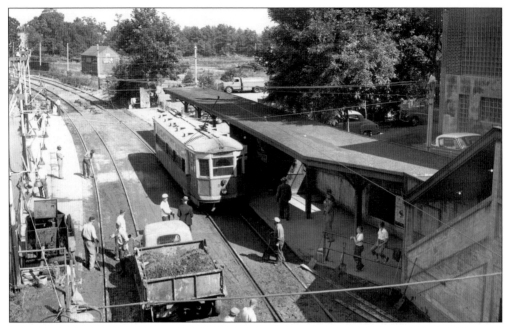

This photograph of Milton Station from the Adams Street bridge was taken on August 29, 1955. The view shows a Type 5 trolley leaving for Ashmont station as workmen clean up the debris from a flood caused by several days of heavy rain, during which the Neponset River overflowed its banks and flooded the station area. Note that the Godfrey Coal Company site to the right is now a parking lot.

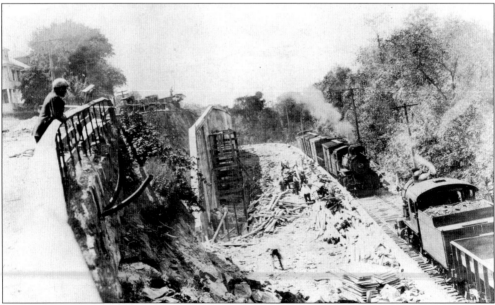

This August 8, 1929 view from Eliot Street in Milton looks down on the Shawmut Branch between the Milton and Central Avenue Stations, where the single-track right-of-way is being widened to accommodate two trolley tracks and one railroad track. A local freight train, inbound from Mattapan, is waiting for the train in the foreground. It has just unloaded construction supplies to back into a siding.

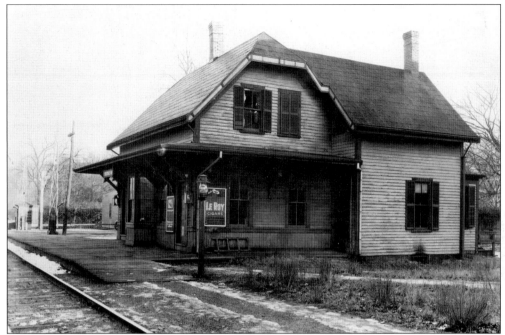

Today's station at Central Avenue in Milton Village bears no resemblance whatever to the original Central Avenue station, shown here. Built when the line was opened in December 1847, the station resembles a combination house and railroad station because it was just that—with the station agent and his family residing in the rear and upper floor of the building. It was demolished in September 1929.

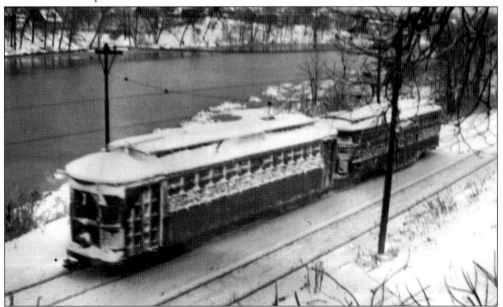

It is a cold January day in 1934 with wind-driven snow being plastered onto this Type 4 motor car and trailer heading for Mattapan Station. This scene is between the Central Avenue and Valley Road stations, with the Neponset River just behind the trolleys. Passengers were able to glimpse pheasants, ducks, and other wildlife in season along this section of the line.

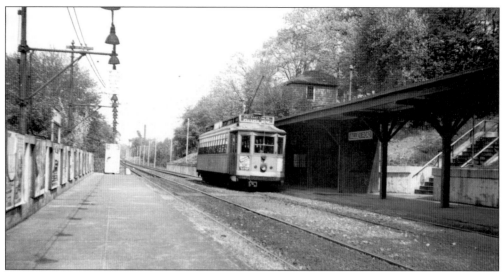

The Shawmut Branch–Mattapan line did not have a station at Valley Road until the line was converted to trolley operation when the Boston Elevated added Valley Road, seen here with an Ashmont-bound trolley on May 15, 1938. Two additional stations were later added at Butler and Capen Streets.

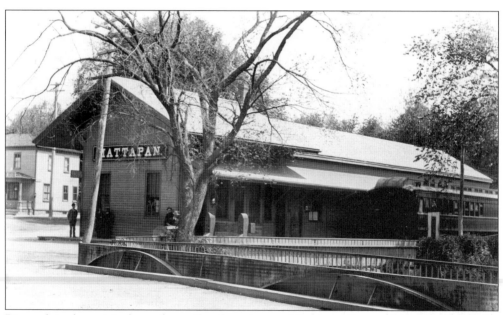

Pictured is the original wooden railroad station at Mattapan Square. It was built by the Dorchester & Milton Branch Railroad in 1847 and was immediately leased to the Old Colony line. This photograph was taken in 1895 or 1896 just before the city of Boston undertook major improvements to Mattapan Square, including the widening of Blue Hill Avenue and construction of a new bridge.

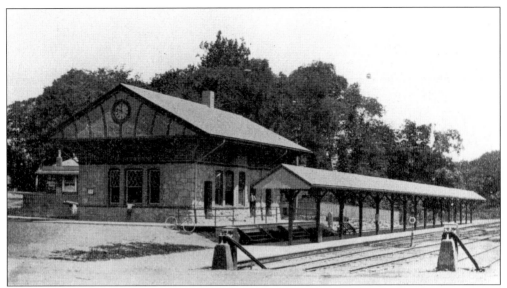

After the city of Boston completed the improvements to Mattapan Square, the New Haven Railroad did its part by building an attractive new stone station to serve commuters on the Mattapan–South Station Shawmut Branch. This station survives today as a pizza restaurant.

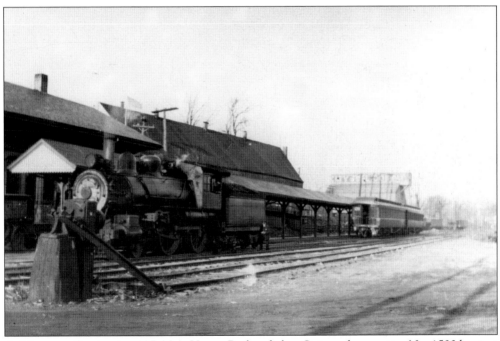

At Mattapan Station in 1927, New Haven Railroad class C steam locomotive No. 1533 has just uncoupled from its short train and will proceed to the nearby turntable to be turned around for the return trip to Boston over the Shawmut Branch. The large coal pocket of the City Fuel Company in the background will soon be torn down.

On January 24, 1928, the Mattapan railroad yard is not very busy. The locomotive turntable is to the left. The freight house is in the center, with the passenger station to the right. By the end of 1929, this yard was serving trolley cars and buses, and the Shawmut Branch was converted to the Mattapan–Ashmont trolley line.

Prior to its acquisition of the Mattapan railroad yard, the Boston Elevated Railway's trolley cars operated from a small, cramped car-storage yard on River Street next to the railroad yard. In this view, a trolley exits the yard onto River Street, en route to Egleston Square via Blue Hill Avenue. This yard is now a park-and-ride lot for transit riders.

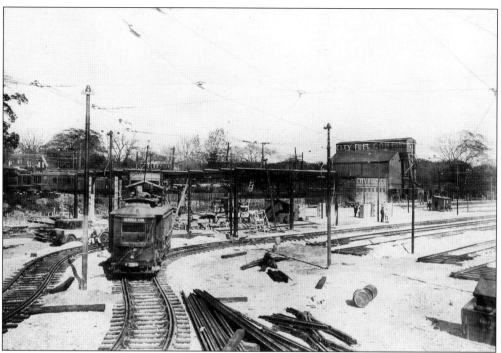

The transformation of the Mattapan railroad yard into a transit transfer station is well under way on October 28, 1929. The steel framing of the station is completed, and much of the new track has already been laid. In the center is trolley No. 231, a wire-maintenance car being used to erect the new trolley wire in the yard.

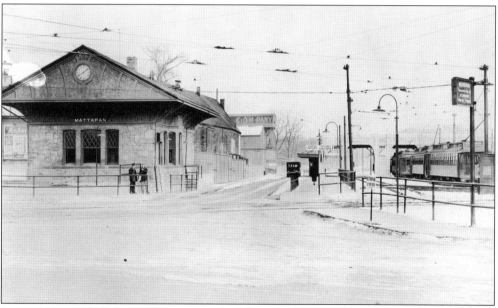

It is a cold and bleak day on January 27, 1930, but operations are running smoothly at the new Mattapan trolley and bus station. Several trolleys are lined up, awaiting their departure time for Ashmont Station. The former railroad station is now an office and lobby for Boston Elevated employees, later becoming a barbershop and then a pizza restaurant.

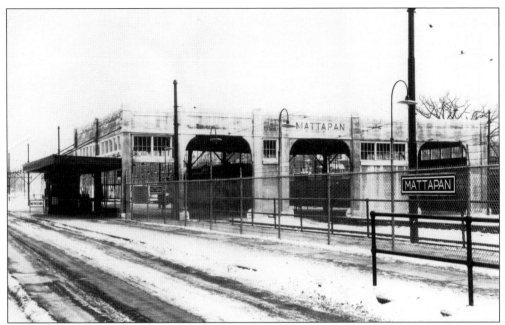

It is January 27, 1930, at the handsome new Mattapan transfer station, which is certainly not very busy. Little change has taken place at this station over the years, and it still looks the same today after 72 years of service to Dorchester and Milton transit riders.

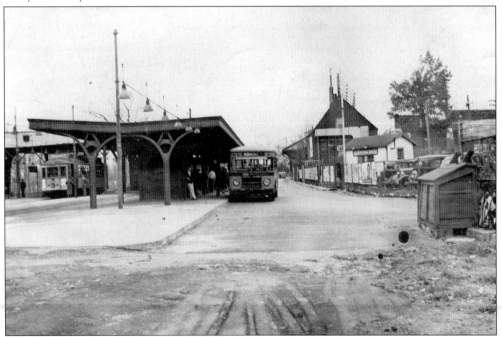

Had the second portion of the Dorchester rapid-transit loop over the Midland Division been completed, a short section of subway would have connected the Midland Line with Mattapan Station. A subway level would have been located beneath this surface station at Mattapan. In this 1932 view, a trolley and a bus are about to depart from Mattapan for Ashmont Station, each by a different route along the Neponset River.

Six

RAPID TRANSIT TO THE SOUTH SHORE

After nearly 30 years of dispute, rapid-transit service to the South Shore began operation as far as Quincy Square in September 1971. Taken on May 23, 1971, this view shows the first test train carrying engineers and officials southbound on the new line at Columbia Station.

1926 (handwritten)

| | | | BOSTON TO BUZZARDS BAY | | | | | | | | | | | BOSTON 43 DIVISION. |

SOUTHWARD.

Distance from Boston	STATIONS.	Distance between Stations	5001 Ex. Sun.	5303 Sun. only	5305 Sun. only	5005 Ex. Sun.	5009 Ex. Sun.	5007 Ex. Sun.	5015 Ex. Sun.	5023 Ex. Sun.	5017 Ex. Sun.	5503 Ex. Sun.	5019 Ex. Sun.
			1st Class Paper	1st Class Paper	1st Class Plymo'th Passenger	1st Class Passenger	1st Class Passenger	1st Class Passenger	1st Class Passenger	1st Class Gr'nbush Plymo'th Passenger	1st Class Plymo'th D. H. Passenger	1st Class Passenger	1st Class Passenger
			A M	A M	A M	A M	A M	A M	A M	A M	A M	A M	A M
0.00	BostonN	0.00	3.30	4.30	5.00	5.36	6.06	6.09	6.26	6.29	6.33	7.06
0.73	South Boston.......	0.73	3.32	4.32	5.02	s 5.39	6.08	s 6.12	6.28	6.31	6.35	7.08
2.38	Crescent Avenue...	1.65	s 5.43	s 6.16
2.97	Savin Hill..........	0.59	s 5.45	s 6.18
3.64	Harrison Square .D	0.67	q 3.38	4.37	5.07	s 5.48	6.13	s 6.20	6.33	6.36	6.40	7.13
4.28	Pope's Hill........	0.64	s 5.50	s 6.22
4.94	Neponset........N	0.66	3.42	s 5.53	s 6.24
5.49	AtlanticN	0.55	q 3.44	s 4.42	5.11	s 5.56	6.17	sA6.26	6.37	6.40	6.44	7.17
6.12	Norfolk Downs	0.63	q 3.45	s 4.44	s 5.58	s 6.19		s 6.45
6.71	Wollaston	0.59	s 3.49	s 4.46	5.13	s 6.01	s 6.22	Via West Quincy	6.39	6.43	s 7.20
7.99	Quincy	1.28	s 3.55	s 4.57	s 5.17	s 6.07	s 6.26		6.41	s 6.46	6.50	s 7.24
8.71	Quincy Adams.....	0.72	s 4.05	s 5.02	s 6.10	s 6.29	
10.14	BraintreeN	1.43	s 4.08	5.05	sA5.21	s 6.14	s 6.33	s 6.43	s 6.47	sA6.51	6.54	A 7.29
11.38	South Braintree .N	1.24	s 4.12	s 5.12	s 6.20	A 6.36	A 6.47	s 6.53	sA6.58	7.10
12.91	Braintree Hl'ds..D	1.53	4.15	5.15	s 6.24	f 6.57	7.15
14.98	Holbrook	2.07	q 4.18	s 5.21	s 6.29	s 7.02
16.79	Avon............	1.81	q 4.21	s 5.25	s 6.34	s 7.07
18.49	Montello	1.70	s 4.25	5.27	s 6.39	s 7.12
20.02	Brockton........N	1.53	s 5.10	s 5.39	s 6.46	s 7.19
21.61	CampelloN	1.59	s 5.15	s 5.44	s 6.51	s 7.24
23.72	MatfieldD	2.11	s 6.59	s 7.28
24.94	Westdale..........	1.22	s 5.21	s 5.50	s 7.02	s 7.30
26.11	Stanley	1.17	s 7.05	s 7.33
26.94	BridgewaterD	0.83	s 5.26	s 5.56	A 7.08	s 7.39
28.76	Flagg Street......	1.82	f 7.43
30.45	Titicut............	1.69	s 5.33	s 6.03	s 7.47
34.62	MiddleboroN	4.17	A 5.40	A 6.10	A 7.55
39.53	Rock	4.91	f	5524
41.66	South Middleboro D	2.13	f	5581
45.55	TremontD	3.89	f	5587
47.15	South Wareham...	1.60	f	
48.31	Parker Mills......	1.16	f	
49.25	WarehamD	0.94	f	665
51.32	OnsetD	2.07	f	665
54.60	Buzzards Bay....N Arrive	3.28	f	663
			A M	A M	A M	A M	A M	A M	A M	A M	A M	A M	A M
	Note references		Q				Z						Z

Q (q) Will slow down, or stop when necessary to leave papers. Z Will not run Feb. 22, April 19 or May 31, 1926.

(L. B.)

Here is a portion of the January 1926 commuter rail timetable for the Old Colony Division trains running through Dorchester, Quincy, Braintree, and beyond. It is interesting that the commuter trains served 13 stations between Boston and South Braintree, but the new Red Line provided service to only 6 stations.

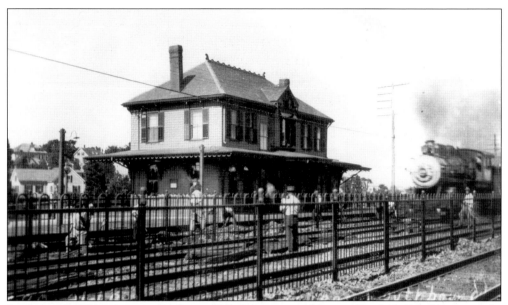

In this mid-1920s view at the Popes Hill Station near Victory Road in Dorchester, track-maintenance workers stand aside as a South Shore express speeds past on the center express tracks. Requests by Neponset–Popes Hill area residents for a station on the new Red Line at this point were declined by the Massachusetts Bay Transit Authority.

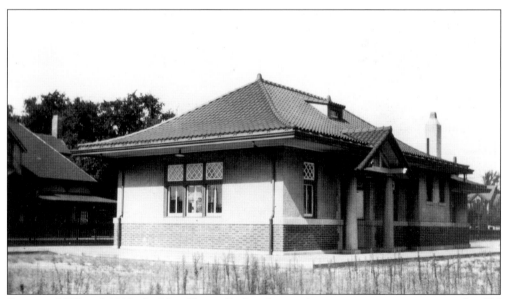

Between 1907 and 1912, the New Haven Railroad carried out major improvements on the Old Colony Division main line between Savin Hill and Quincy. The improvements included four-tracking, new stations, and elimination of grade crossings. Pictured is the new Neponset northbound station, designed in a Mission style favored by the New Haven Railroad at the time. The traditional-style southbound station is to the left.

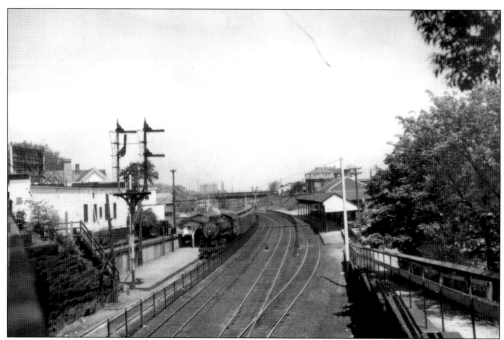

Had it been completed, the New Haven Railroad's plan to four-track the Old Colony main line as far south as Braintree to permit express trains to bypass local stations in Dorchester and Quincy would have benefited riders from Plymouth and Cape Cod. However, financial problems cancelled the project south of Atlantic Station, pictured in April 1948 from the Hancock Street bridge in Quincy.

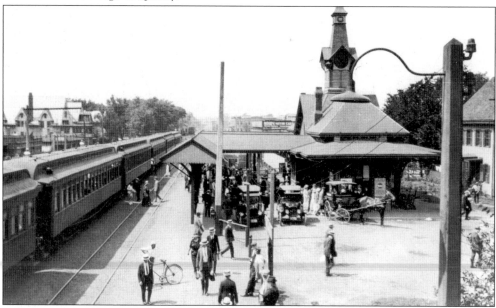

Called Wollaston Heights, this interesting station was located on the west side of the tracks when it was built in 1877. When the Old Colony changed from English-style, left-hand running to regular, right-hand operation in 1895, this station was moved across the tracks. In this mid-1920s view, a southbound rush-hour train is letting off passengers.

The Old Colony Division station at Quincy Square was the most heavily used on the Boston–Braintree section of the line. This rather attractive brick station, pictured in March 1948, saw its last commuter train in July 1959. It has been replaced by a huge parking garage housing a rapid-transit station, which opened on September 1, 1971.

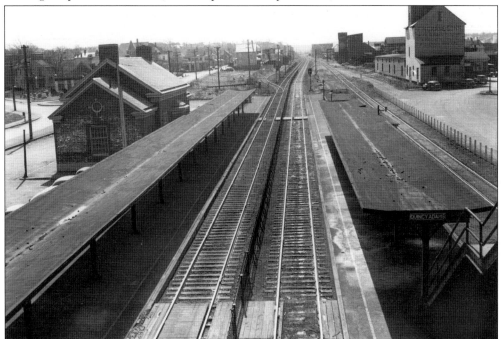

The brick Colonial-style station at Quincy-Adams also closed in July 1959 with the abandonment of commuter rail service. Like the Quincy Square Station, it was replaced by a colossal parking garage housing a Red Line station. However, it took an astonishing nine years before the section of the Red Line between Quincy and Braintree was completed in March 1980.

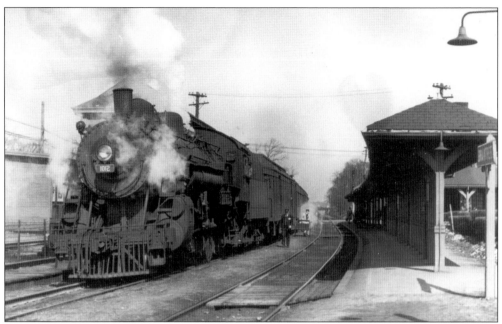

New Haven Railroad locomotive No. 1012 has just arrived at the Braintree Station and is about to turn around on the Braintree wye track for the return trip to Boston in this March 1948 view. Newspapers and packages were also delivered on the local trains at this time and are about to be unloaded from the baggage car on this train.

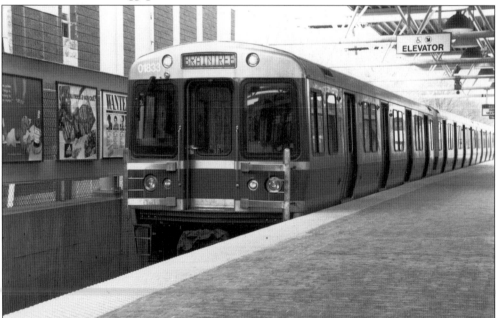

In May 1966, the Massachusetts Bay Transit Authority announced the new Red Line from Boston to Braintree. More than nine miles would be ready for service in May 1969 and would cost $41 million. However, it would be March 1980 (11 years and $111 million later) when the line to Braintree was finally completed. In this April 1994 scene at Braintree Station, a train of new 01800-class cars is about to leave for Boston.

Seven

ROLLING STOCK

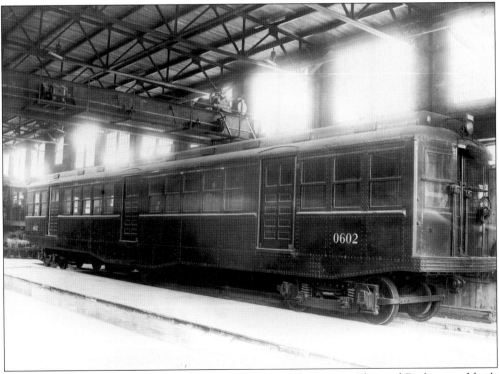

Designed by chief equipment engineer John Lindall of the Boston Elevated Railway and built by the famous Diamond Jim Brady's Standard Steel Car Company, the new Type 1 Cambridge Tunnel cars (such as car No. 0602, seen here at the Eliot Square shops in November 1911) were regarded as revolutionary in design and performance by the railway industry when they were introduced with the opening of the Cambridge Tunnel line.

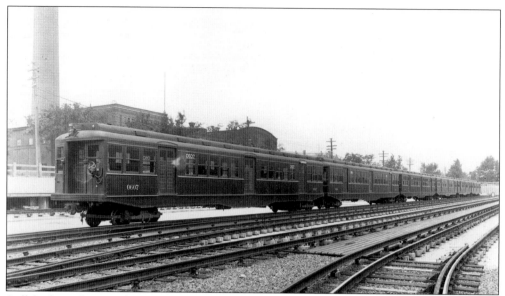

Still looking shiny and new after five months of heavy use, this six-car train of Cambridge Tunnel cars is seen at the Eliot Square shops on August 26, 1912, with the Boston Elevated's Harvard Power Station in the background. The cars were painted a conservative olive green, with dark-red window frames and black hardware.

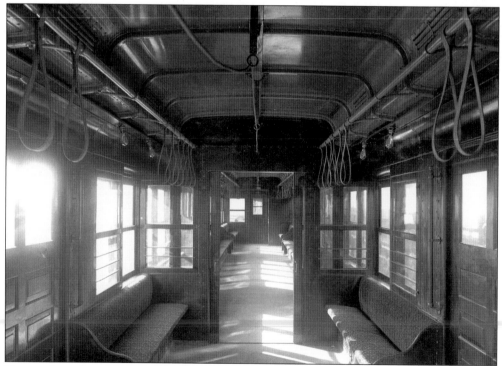

Here is the rather gloomy interior of tunnel car No. 0601 when it was new. The all-steel car's interior was painted a dark mahogany to resemble wood, with a dark-green ceiling trimmed in gilt. The seat cushions were plush in a red-and-black mottled pattern. The brown leather straps were for standees. The sliding doors closed off the smoking compartment.

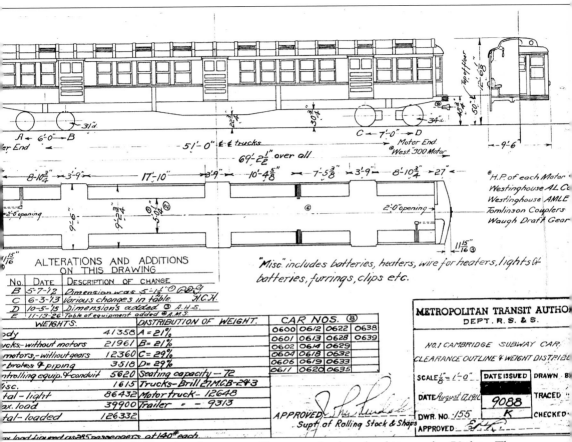

Top of floor

$A \leftarrow 6'-0'' \rightarrow B$

$\leftarrow 51'-0''$ ℄ ℄ trucks

$69'-2\frac{1}{2}''$ over all

$C \leftarrow 7'-0'' \rightarrow D$

Motor End.
West 300 Motor

$\leftarrow 9'-6$

31"d.

34"d.

$8'-10\frac{3}{4}'' \rightarrow 3'-9'' \rightarrow$ $17'-10'' \rightarrow 3'-9'' \rightarrow 10'-4\frac{5}{8}'' \rightarrow 7'-5\frac{3}{8}'' \rightarrow 3'-9'' \rightarrow 8'-10\frac{3}{4}'' \rightarrow 27'' \rightarrow$

er End.

2'-0"opening

9'-6

9'-2\frac{1}{4}

5'-0\frac{1}{2}

2'-0"opening

$11\frac{15}{16}''$

ⓔ H.P. of each Motor
Westinghouse AL Co
Westinghouse AMLE
Tomlinson Couplers
Waugh Draft Gear

ALTERATIONS AND ADDITIONS
ON THIS DRAWING

"Misc." includes batteries, heaters, wire for heaters, lights &
batteries, furrings, clips etc.

No.	Date	Description of change
B	5-7-'12	Dimension was 5-1⅛"Ⓓ Ⓑ.Ⓒ.Ⓗ.
C	6-3-13	Various changes in table. H.C.H.
D	10-5-'15	Dimension's added Ⓓ A.H.S.
E	11-13-26	Table of equipment added Ⓔ A.M.S.

WEIGHTS:		DISTRIBUTION OF WEIGHT.
...ody	41358	A = 21%
...ucks - without motors	21961	B = 21%
...motors, - without gears	12360	C = 29%
...brakes & piping	3518	D = 29%
...ntrolling equip. & conduit	5620	Seating capacity — 72
...isc.	1615	Trucks — Brill 27 MCB-2¾3
...tal - light	86432	Motor truck - 12648
...ax. load	39900	Trailer " - 9313
...tal - loaded	126332	

...load fiqured as 285 passengers at 140# each.

CAR NOS. Ⓑ			
0600	0612	0622	0638
0601	0613	0628	0639
0602	0614	0629	
0604	0618	0632	
0606	0619	0633	
0611	0620	0635	

METROPOLITAN TRANSIT AUTHO...
DEPT. R. S. & S.

NO.1 CAMBRIDGE SUBWAY CAR.
CLEARANCE OUTLINE & WEIGHT DISTRIBU...

SCALE ⅛" = 1'-0"	DRAWN B...
DATE August 17, 1910	TRACED ...
DWR. NO. 155	9088 K CHECKED...
APPROVED	

APPROVED
Supt of Rolling Stock & Shops

These new cars had a weight of just over 43 tons and a length of just under 70 feet. They
featured two 225-horsepower motors, a smoking compartment, and a rated capacity of 285
passengers (of which 72 were seated). The cars created quite a stir in the transit industry when
they were introduced in 1912 and were soon copied by the Brooklyn rapid-transit system.

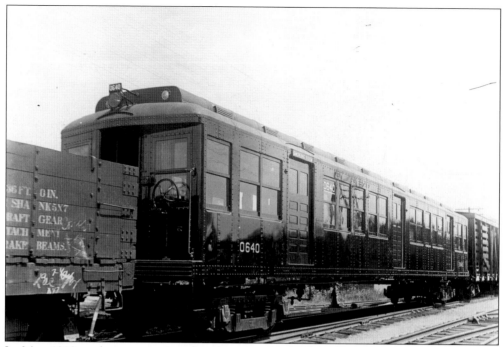

In May 1912, only two months after the new Cambridge Tunnel opened, the constantly increasing ridership made it necessary to order 20 additional cars, which were provided by the Laconia Car Company of New Hampshire. In this view, Cambridge Tunnel car No. 0640 is glistening in its new paint in July 1913, en route to Boston in a freight train.

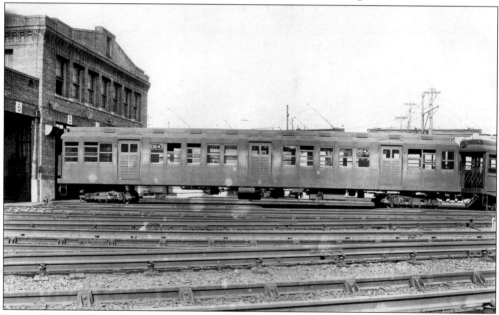

Pictured at the Eliot Square car shop in 1926 is one of the Laconia-built Type 2 Cambridge Tunnel cars, which used a slightly different frame design from Types 1, 3, and 4. The Type 2 design made the cars appear to be longer than the other cars, but all Cambridge Tunnel cars were the same length and width.

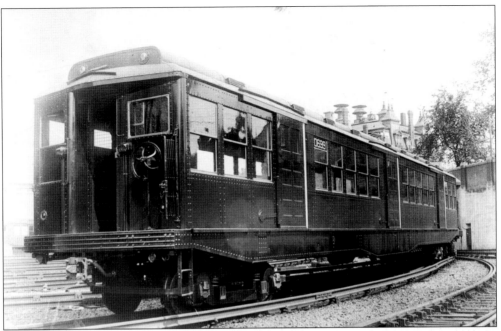

Extension of the Cambridge–Dorchester tunnel to Andrew Square (1917) and to Ashmont (1928) required additional cars. In 1917, 35 Type 3 tunnel cars were ordered from the Pressed Steel Car Company. In 1926, 60 Type 4 cars were purchased from the Osgood Bradley Car Company.

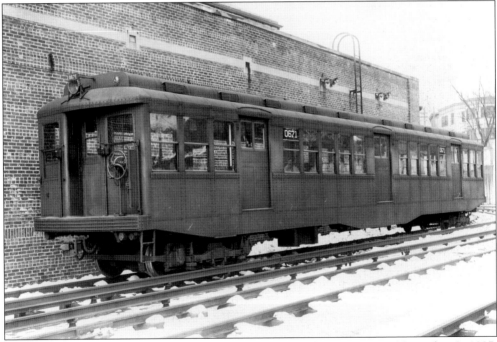

One of the new Type 4 cars (No. 0699) is seen here at Eliot Square on November 2, 1927. Purchased from the Pressed Steel Car Company in 1917, Type 3 tunnel car No. 0671 was one of the 30 cars acquired for the extension of the Dorchester Tunnel to Andrew Square. It remained in service until it was retired on September 10, 1963, after 46 years of trouble-free service.

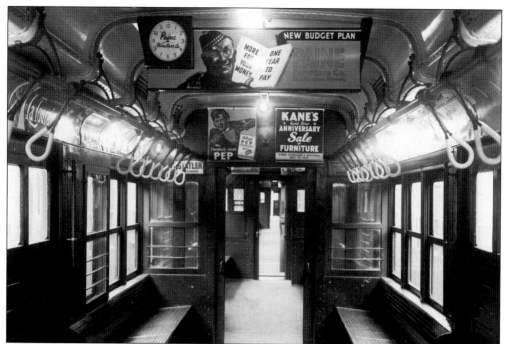

Shown in the late 1920s is the interior of a Type 1 tunnel car just after a trip through the car shops to alter the design. The dark mahogany paint was replaced by apple green with white ceilings. Wooden seats replaced plush seat cushions, and white metal hand grips replaced the leather straps. Note the electric clock on the Paine Furniture Company advertising panel.

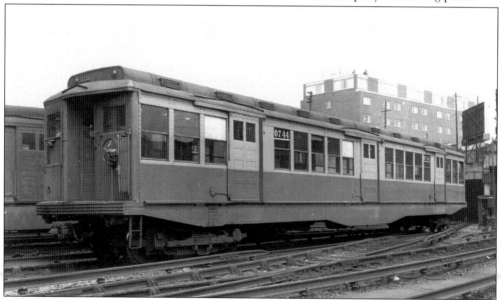

Beginning in 1953, the interior of the Cambridge Tunnel cars was brightened up with new paint and lighting. The exteriors remained in the dark olive-green color. In May 1960, a gray-and-tangerine exterior color scheme was adopted, as seen here on car No. 0744 on July 25, 1961, at the Eliot Square shops. In the background, a modern motel occupies the former Cambridge police station site.

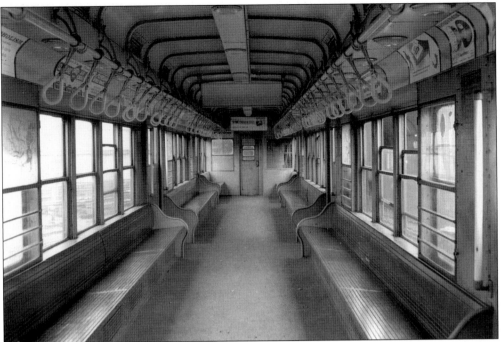

The interior of Type 3 tunnel car No. 0670 received a new light-blue paint scheme and modern lighting, as seen here on July 25, 1961. The passenger capacity of these cars was rated at 285 people. However, actual counts taken during rush-hour periods in the early 1940s revealed that up to 412 passengers were being stuffed into these cars, enabling a four-car train to move more than 1,200 people.

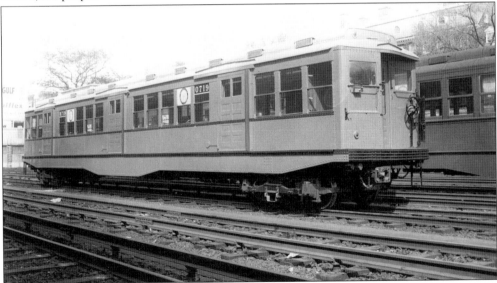

In the spring of 1948, the Metropolitan Transit Authority (which had taken over the Boston Elevated in September 1947) proposed to upgrade and modernize most of Boston's rapid-transit fleet and rebuilt one four-car train as a sample. Pictured is car No. 0719, resplendent in bright orange with a gray roof and maroon-and-black trim at the Eliot Square shops, where the work was done.

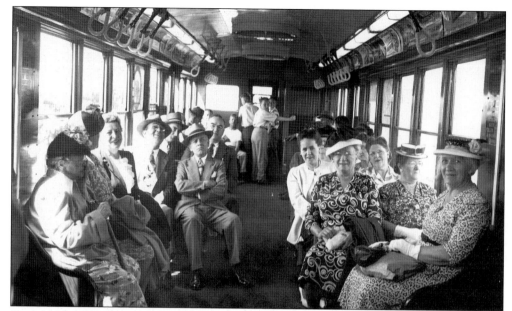

On July 15, 1948, the modernized train of 1927 Cambridge Tunnel cars was placed in service. With its new lighting, comfortable leather seating, and bright colors, most riders thought the train was brand new. In this view, that train is inbound from Ashmont to downtown with a group of smiling, well-dressed passengers. In 1948, people still dressed up to go "in town."

In December 1961, new cars were ordered from Pullman-Standard to replace the now aging fleet of Cambridge Tunnel cars. The new cars would be wider than the existing cars, and various lights, cables, and signals on the tunnel walls would have to be moved. Car No. 0642 is shown fitted with clearance boards on July 23, 1962, to determine the location of tight clearances in the tunnels.

On December 26, 1962, Pullman-Standard was awarded a $10 million contract for 92 new Type 5 Cambridge Tunnel cars. In this December 1962 view, we see two of the new cars at Pullman's assembly plant at South Chicago, Illinois. On February 14, 1963, the first set of new cars arrived in Boston.

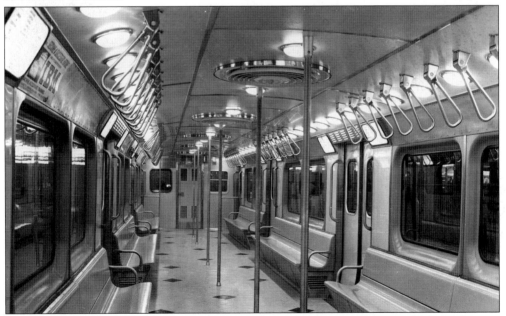

Unfortunately, the new cars were the victims of extreme cost cutting. Cushioned seats, fluorescent lighting, and air conditioning were all cancelled from the specifications. The cars were very unpopular with riders right from the beginning, with rough riding, excessive noise, and hard, uncomfortable seats being the source of constant complaint.

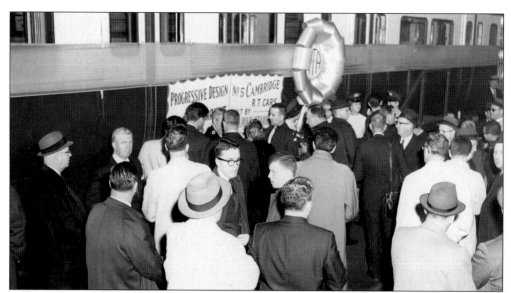

On April 24, 1963, an official presentation of the new Type 5 Cambridge Tunnel cars was held at the Eliot Square shops for the press and civic officials. It was followed by a demonstration trip to Ashmont and then a dinner at a Cambridge hotel. This view shows the guests milling about just before the official ribbon cutting.

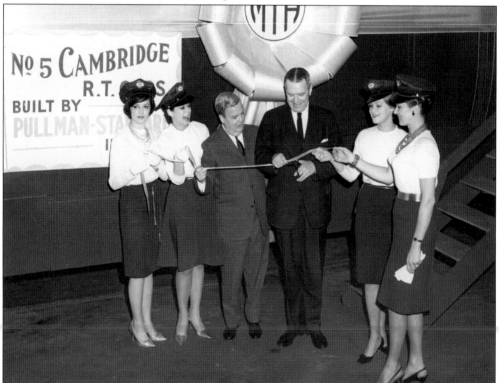

Daniel Tyler, chairman of the Metropolitan Transit Authority's board of trustees, performs the official ribbon cutting. He is assisted by a covey of attractive Metropolitan Transit Authority secretaries and a representative of the Pullman-Standard Company.

This photograph was also taken at the April 24, 1963 presentation ceremony. From left to right are an unidentified television newscaster, Metropolitan Transit Authority chairman Daniel Tyler, an unidentified hostess, and general manager Thomas McLernon. McLernon is looking very satisfied, as he had recently won two political victories over the Boston Carmens Union and the state legislature and had forced the purchase of new Cambridge Tunnel cars.

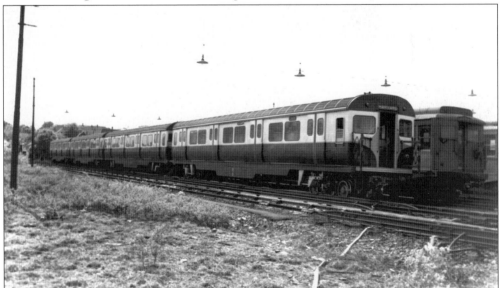

Pictured at Codman yard on May 15, 1963, is what might be termed the changing of the guard—the new Type 5 Cambridge Tunnel cars are gradually replacing the older cars, both of which can be seen here. The last of the old cars were retired on November 23, 1963, as the noisy and unpopular new cars took over all runs.

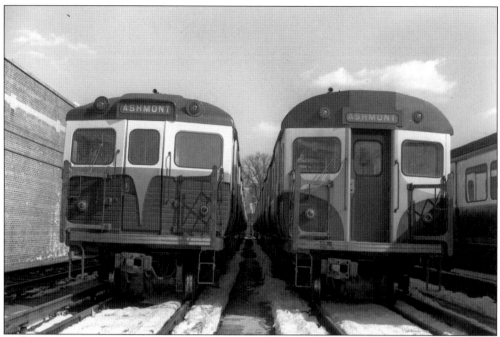

As the Type 5 Cambridge Tunnel cars were in production, the Pullman-Standard Company persuaded the Metropolitan Transit Authority to equip two of the cars with experimental fiberglass ends, one of which is seen here on the left at the Eliot Square shops on February 28, 1964. The idea proved popular, and both Cleveland and Chicago soon purchased cars with fiberglass ends from Pullman.

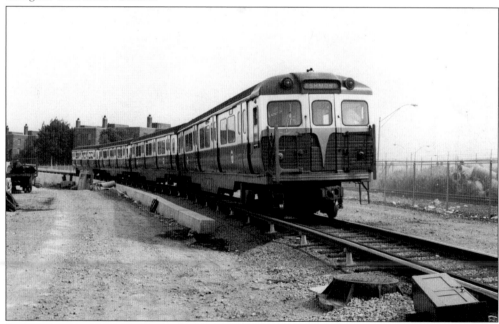

In this 1967 scene, construction is under way on the new junction of the South Shore Red Line extension with the existing Ashmont line at Columbia Station. A Cambridge-bound train from Ashmont is passing, with one of the fiberglass-ended cars bringing up the rear.

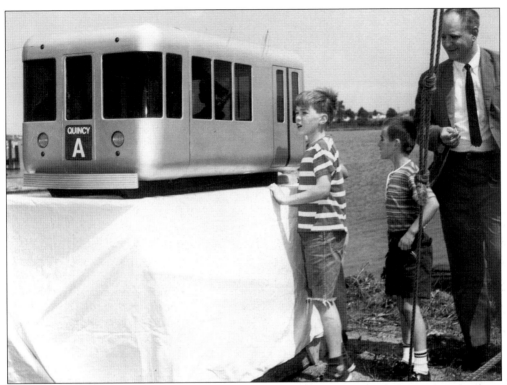

In January 1965, the Massachusetts Bay Transit Authority hired a firm of design consultants to upgrade the transit system's image. Although the designers had no railway or equipment experience, they made a costly attempt to design a new Red Line car. As seen here, a mock-up of the car was unveiled to South Shore residents at the Weymouth Rotary Club on July 10, 1966. The rather impractical design was rejected by the car-building firms.

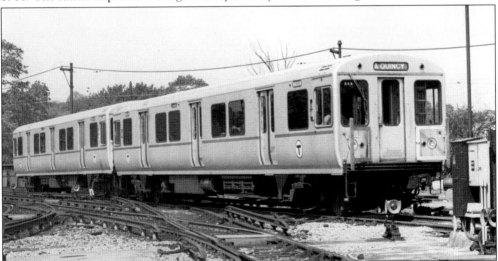

After the rejection of the consultants' design, the Massachusetts Bay Transit Authority's own equipment engineers, in cooperation with the Pullman-Standard Company, provided a design both practical and attractive for the new Type 1 South Shore cars, seen here at Codman yard. These cars, introduced in December 1969, were Boston's first aluminum transit cars.

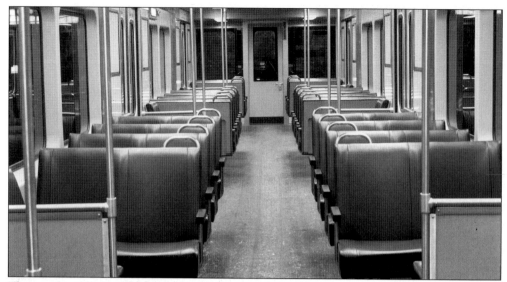

The comfortable forward-facing seats in the new South Shore cars did not last long because they hindered passenger movement, causing congestion at stations and slowing down rush-hour train operation. Replaced by standard bench-type subway seating, these comfortable seats were installed in recently overhauled suburban commuter cars.

In this July 1969 photograph, top Massachusetts Bay Transit Authority (MBTA) officials inspect the first of the new South Shore Red Line cars at the Pullman plant. Second from the left is Leo J. Cusick, MBTA general manager. Third from the left is Judge Charles Cabot, MBTA board chairman. The other two gentlemen are Pullman-Standard officials.

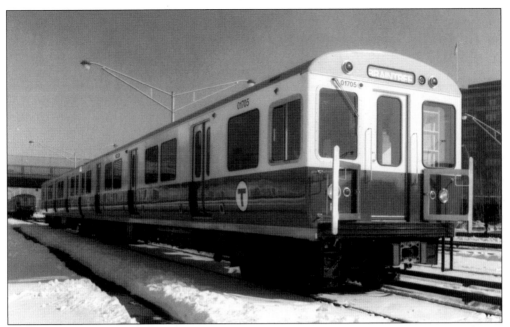

In the early 1980s, increased riding on the Red Line required the purchase of additional cars. In January 1984, the Massachusetts Bay Transit Authority purchased 58 Type 2 South Shore cars from Can-Car Rail of Ontario, Canada. Pictured on January 12, 1988, are two of the new red-and-white cars at the Cabot Center shop in South Boston.

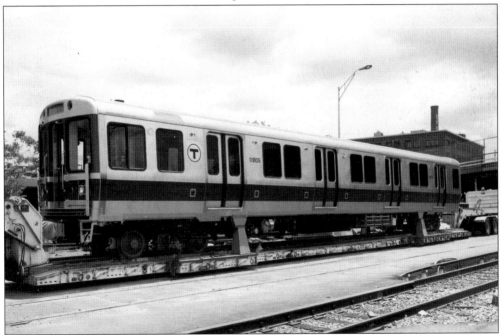

In December 1990, the Massachusetts Bay Transit Authority ordered 86 new cars from Bombardier of Montreal, Canada, to replace the noisy and rough-riding Type 5 Cambridge Tunnel cars. In this May 26, 1993 view, one of the handsome red-and-silver cars is being delivered to the Cabot Center shops from Bombardier's Vermont plant.

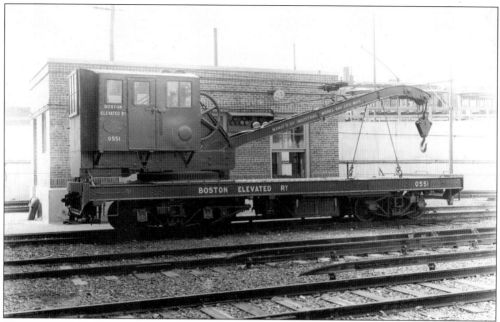

There are some types of rapid-transit equipment that the public rarely glimpses, such as this heavy crane car (No. 0551), which served both as a wrecker and a track-maintenance car. Now in a railway museum, it is seen here at the Eliot Square shops in April 1912 shortly after delivery from the Industrial Works of Bay City, Michigan.

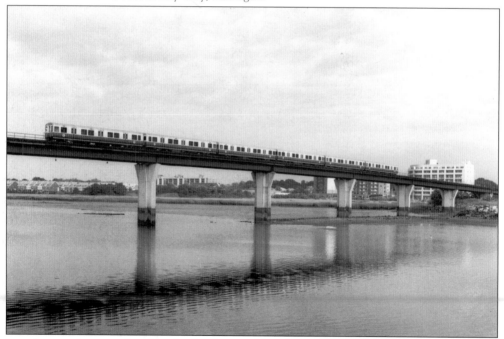

It took more than two decades of politicking and legislative action to overcome the opposition of some South Shore residents to the much needed Red Line extension through Quincy to Braintree. In this view, a Cambridge-bound train crosses the Neponset River Bridge, with some of the real estate development spurred by the line visible in the background.